The College History Series

WAKE FOREST
UNIVERSITY

(On the Cover) THE ARCH OF **1909.** The Arch of 1909 is the symbol of Wake Forest College to many graduates of the old campus. It was a gift to the college from the Class of 1909, whose names were chiseled on the back.

The College History Series

WAKE FOREST UNIVERSITY

THOMAS K. HEARN III
with GENE T. CAPPS, CHAPLAIN EDGAR D. CHRISTMAN,
DR. J. EDWIN HENDRICKS, AND DR. EDWIN G. WILSON

ARCADIA

First published 2003.
Reprinted 2004.

Published by Arcadia Publishing
an imprint of Tempus Publishing Inc.
Charleston SC, Chicago, Portsmouth NH, San Francisco

Printed in Great Britain

Library of Congress Catalog Card Number: 2003112421

For all general information contact Arcadia Publishing at:
Telephone 843-853-2070
Fax 843-853-0044
E-mail sales@arcadiapublishing.com
For customer service and orders:
Toll-Free 1-888-313-2665

Visit us on the internet at http://www.arcadiapublishing.com

This book is dedicated to my father, Dr. Thomas K. Hearn Jr. and in memory of my grandmother, Louise Patton Hearn.

CONTENTS

ACKNOWLEDGMENTS

In the fall of 2003, my father celebrated his 20th year as president of Wake Forest University. Several years ago at an antiques show, I discovered some turn-of-the-century postcards of the old campus. I bought the postcards thinking that they might make an interesting gift for my father. An attempt to put together a larger collection of pictures, followed by the realization that others might be interested in a photographic history of the university, gave birth to this project. My family has established the university's Louise Patton Hearn Scholarship for Humanitarian Service to honor my grandmother and to assist students who have helped others in a meaningful way. All of the authors' proceeds from sales of this book will be contributed to this scholarship fund.

George Washington Paschal's three-volume *A History of Wake Forest College* was a primary reference for this book, as was Bynum Shaw's *The History of Wake Forest College*.

I realized early on that many of the university's traditions and oral histories harken back to the old campus. I am indebted to Gene Capps, the Director of the Wake Forest Birthplace Society, who located photographs and toured me around the old campus. Dr. Ed Christman, retired chaplain at Wake Forest, recalled many great stories that had never found their way into written history. Dr. Ed Hendricks, professor of history, patiently answered my frequent questions and ensured that facts were correct. Dr. Ed Wilson, University Provost Emeritus, vividly recounted his recollections of student life and the town of Wake Forest from both student and faculty perspectives. Weston Hatfield and Denny Spear shared their reminiscences about the old campus with me.

Lisa Persinger and Julia Bradford in the university archives enthusiastically helped me with this project, and they were a joy to work with. Skeeter Francis and Maurice George shared their knowledge of the athletics program to produce the athletics chapter, while Dean Buchan and Terri Nunn in the athletics department helped locate relevant photographs.

Mark Tolliver and Will Scott were particularly helpful in identifying and locating photographs. Michael Strysick not only tracked down important details but also provided invaluable editing assistance. Ken Bennett, university photographer, was a great help in locating more recent pictures.

I especially want to thank my wife, Dana, and our sons, Patton, Sam, and Cooper, who were supportive of this project and permitted me to work on it during family time.

INTRODUCTION

Wake Forest College was organized in 1834 on a former farm north of Raleigh. Founded by the North Carolina Baptist Convention, the school was established to train Baptist ministers in a time when few institutions of higher learning existed in the South. The college's first president, Samuel Wait, worked tirelessly to raise money and organize the academic curriculum. The school remained relatively small throughout the remainder of the century, and, like many southern institutions, was fortunate to survive the fiscal and manpower shortages resulting from the Civil War. It took almost 20 years for the school's endowment to return to prewar levels.

Enrollment grew in the post-war years and increased from 17 in January 1866 to 534 in 1919. As education became more specialized, new schools were added to the curriculum. The School of Law was founded in 1894 and the School of Medicine was organized in 1902. The number of faculty increased from 6 in 1884 to 46 in 1926.

From the 1880s to the 1960s, the college was led primarily by four individuals. Dr. Charles E. Taylor served as president from 1884 to 1905. Dr. William L. Poteat, who led the school from 1905 to 1927, succeeded Dr. Taylor. Dr. Thurman D. Kitchin was the president from 1930 to 1950 and was followed by Dr. Harold W. Tribble, who led Wake Forest from 1950 to 1967. These leaders provided great stability to the college during times of tremendous growth, challenge, and social change.

For many years, the social life of the college was organized around two literary societies: the Euzelians and the Philomathesians. All students were required to join one of these organizations. These literary societies were focused on engaging their members in debate, literary work, and essay. Interest in the societies declined in the 1920s when the college legalized social fraternities. To maintain student enrollment during World War II, women were admitted to the college beginning in 1942.

As a Baptist institution, daily chapel services were required for all students for many years. By the 1940s, mandatory chapel services were reduced to three days per week. Compulsory chapel attendance ended in 1968.

Intercollegiate athletics appeared as part of campus life beginning in the late 1880s. On October 18, 1888, the first college football game in North Carolina was a Wake Forest victory over the University of North Carolina by the score of 3-2. The first Wake Forest baseball game was played in 1891. A Wake Forest instructor was responsible for introducing intercollegiate basketball to the state in 1905. Wake Forest athletics has seen many colorful and successful athletes and coaches over the years, including football coach "Peahead"

Walker, basketball coach "Bones" McKinney, golfer Arnold Palmer, basketball player Tim Duncan, and football player Brian Piccolo. An early member of the Southern Conference, Wake Forest left it in 1953 to become a founding member of the Atlantic Coast Conference.

The town of Wake Forest grew up around the college. Many of the students and college staff lived in private homes in the area, which led to special and long-lasting relationships between the townspeople and the college community. Many students continued to live in private homes until the college relocated to Winston-Salem in 1956. Boarding houses were another important part of the town-gown tradition. The college did not have a campus dining facility until the beginning of World War II, and many people at the college dined at Miss Jo's, Mrs. Harris's, or Mrs. Newsome's boarding facilities. Late night trips to Shorty's, the pool halls, or one of the town's two movie houses were often campus traditions. The college students knew everyone in town, and the citizens of the village of Wake Forest knew the students. These special relationships helped lead to the development of what is referred to as the "Wake Forest Spirit."

The future of the college and the town was changed in dramatic fashion in 1946 when the Z. Smith Reynolds Foundation announced a gift of $350,000 annually and in perpetuity if the college would relocate 110 miles west to the city of Winston-Salem. The medical school had previously moved to Winston-Salem in 1941. Following much debate and controversy, construction of the new campus began with a groundbreaking ceremony attended by President Truman in 1951. The move to the new campus, which was completed in 1956, was traumatic for both the college and the town. Some faculty chose to remain in Wake Forest rather than move to Winston-Salem, and the economic impact on the community was severe. However, the move led to continued growth in the academic programs of the college. The trustees of the college changed the name of the institution to Wake Forest University in 1967.

Dr. James Ralph Scales led the university from 1967 to 1983, and Dr. Thomas K. Hearn Jr. has served as president since 1983. Since the 1960s, the university has changed from a regional institution into a nationally recognized university. Several events were instrumental in the evolution of the modern university. The Board of Trustees entered into a new relationship with the North Carolina State Baptist Convention in 1986. This relationship allowed the school to establish a self-perpetuating Board of Trustees while Wake Forest relinquished any claims to additional financial support from the convention.

In 1987, R.J. Reynolds Corporation donated its Winston-Salem World Headquarters to the university. The corresponding rental revenue associated with this gift allowed the university to make significant investments in new buildings and programs. The Worrell Professional Center, Benson University Center, Olin Physics Laboratory, and the Wilson addition to the Z. Smith Reynolds Library were just a few of the campus improvements made possible by the income from the Reynolds gift. In a reaffirmation of its Baptist heritage, the university opened a divinity school in 1999.

Wake Forest hosted debates for the 1988 and 2000 presidential elections, a further indication of the university's stature on the national scene. An early technology adopter, the university has also been called one of the most "wired" campuses in America for its integration of technology into the academic programs. Today, the Wake Forest School of Medicine, the Law School, and the Babcock Graduate School of Management enjoy national and international reputations, while *US News and World Report* consistently ranks the undergraduate program in the top 30 in the national university category.

One

OLD CAMPUS VIEWS

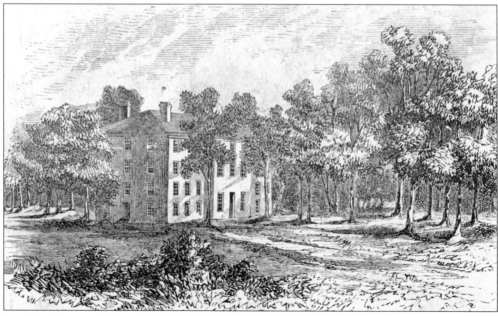

THE OLD COLLEGE BUILDING. For many years, the Old College Building was the only academic structure on the campus. Built in 1837 for $20,000, it was considered one of the finest buildings in North Carolina. It was later renamed Wait Hall for Samuel Wait, the first president of Wake Forest College. In addition to classroom space, this building housed students and student activities and was the first building to be renovated for indoor plumbing in 1894. It was destroyed in a fire in 1933.

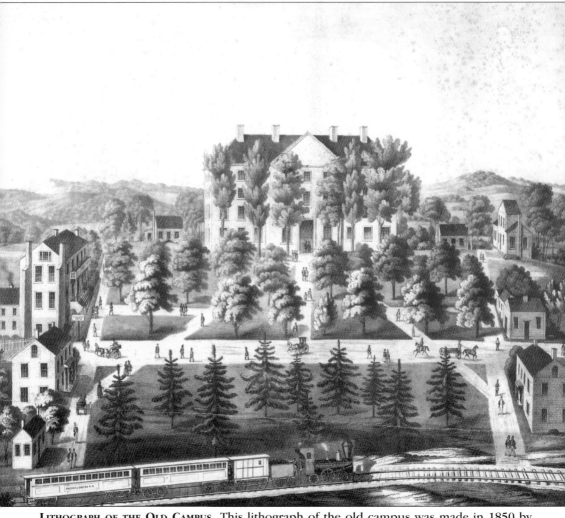

LITHOGRAPH OF THE OLD CAMPUS. This lithograph of the old campus was made in 1850 by Perkins Sun Lithographic Company. Three originals are known to exist. The *c.* 1820 Calvin Jones House, where the college began, can be seen behind and to the left of the Old College Building. The College Hotel is located to the left of the Jones House.

THE CALVIN JONES HOUSE. The Wake Forest Institute, as the college was first known, was located on a large farm or plantation sold to the North Carolina Baptist Convention by Dr. Calvin Jones. This area of Wake County, north of the Neuse River, was generally referred to as the "forest of Wake" because of the many large hardwood trees in the area. Several other schools by the name of Wake Forest were located in the area. Dr. Jones, a strong supporter of education, made the land available at an attractive price. Dr. Jones later moved to Tennessee with his family and became a successful planter.

THE CALVIN JONES HOUSE AND WAKE FOREST BIRTHPLACE MUSEUM. As the college grew, the Calvin Jones House was used for several different purposes and was relocated twice. It was first moved to accommodate the construction of the Old College Building and was later sold and relocated to Wingate Street. It came back into the possession of the college in 1916 when the college purchased it in an estate sale. The Wake Forest College Birthplace Society was formed in 1956 to move and preserve the house. The society now operates the Calvin Jones House as the Birthplace Museum. It is open on a regular basis at 414 North Main Street and can be contacted at (919) 556-2911.

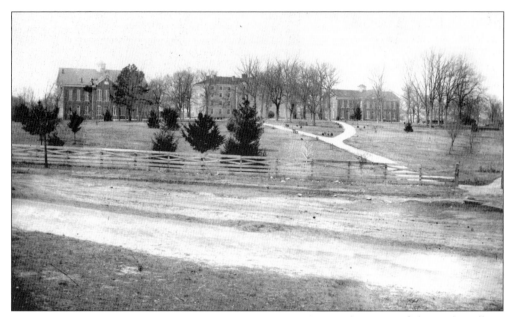

THE EARLIEST KNOWN PHOTOGRAPH OF WAKE FOREST COLLEGE. This view of the early college buildings was taken prior to the construction of the stone wall in the 1880s. The wooden fence was constructed to keep livestock, which roamed freely, off the campus grounds. (Courtesy Wake Forest Birthplace Society.)

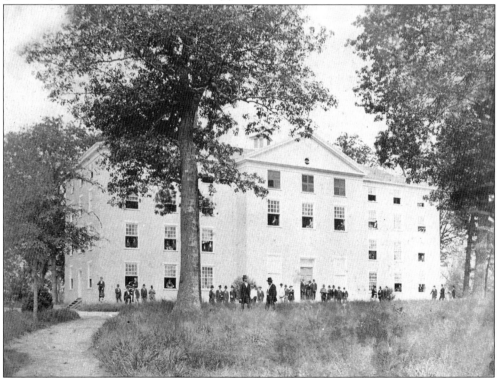

AN EARLY VIEW OF WAIT HALL. Dr. William Wingate and Prof. William Louis Poteat, later president of Wake Forest, are in the foreground.

THE CAMPUS WELL. A campus landmark was the old campus well. The well was dug to supply water for a marble fountain donated by the graduating Class of 1911. The structure shown was built in 1935. The well was donated to the birthplace society in 2001 by the Southeastern Baptist Theological Seminary, which now occupies the old campus, and was relocated next to the Calvin Jones House.

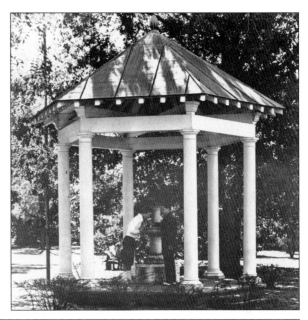

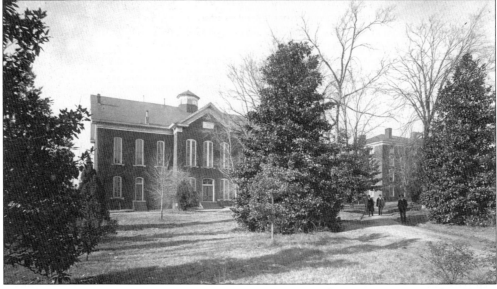

WINGATE MEMORIAL HALL AND THE ARSONIST OF 1933–1934. Wingate Memorial Hall was named for President Washington M. Wingate. A large chapel was located on the second floor and allowed more people to attend the services of the Wake Forest Baptist Church. Church services had previously been held in the smaller chapel in the Old College Building. The second floor also contained a collection of portraits of many important figures associated with the founding and growth of the college. Tragically, those paintings were lost in the fire that destroyed the building in 1934. During 1933 and 1934, several buildings in Wake Forest, including Wait Hall, were destroyed by fires that started after midnight and were ruled acts of arson. Fires in the Hunter Dormitory and the Alumni Building were discovered in time to save the buildings. No arrests were made in conjunction with the crimes, but it was speculated that the arsonist was a student at the college because the fires stopped at the end of the spring 1934 academic session.

THE ALUMNI BUILDING. The Alumni Building, which opened in 1906, was home to the Biological Sciences Department and was the first location of the School of Medicine. During the 1920s, Dr. William Louis Poteat, a professor of biology and later the president of Wake Forest, attracted regional and national attention for his teaching of evolution on campus. He was one of the first professors in the South to invite students to see God's world through a microscope. This topic and Poteat's career are covered extensively in Randal L. Hall's book, *William Louis Poteat, A Leader of the Progressive-Era South*.

THE LEA LABORATORY. When the Lea Laboratory opened in 1888, it was considered the best equipped science building on any college campus in America. This classic Georgian structure was named for Mr. Sidney Lea, who donated $8,000 towards the construction of a chemistry laboratory. This building has been photographed extensively and appears in many early photographs and postcards. It is now listed on the National Register of Historic Places.

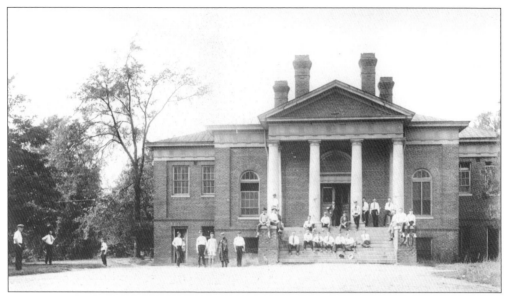

THE OLD GYMNASIUM. Prior to the construction of the gymnasium in 1901, gym classes were conducted on the third floor of the Old College Building. Following the introduction of basketball, spectator seating was added to the gymnasium. Space on campus was at a premium, however, and the basement was used for many things, including dissecting space for the School of Medicine. Following the construction of the Gore Gymnasium in 1935, this building was renamed the Social Sciences Building.

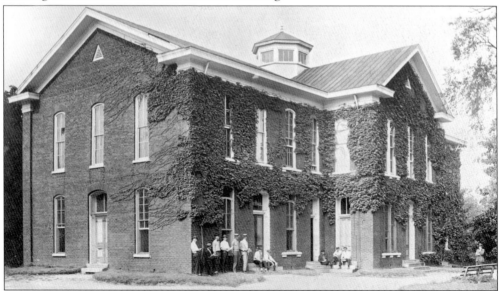

THE HECK-WILLIAMS BUILDING. President Thomas H. Pritchard was an early advocate for new campus buildings. He said they should be "elegant and tasteful structures, and not rude and unsightly barn-like structures." The Heck-Williams building was designed primarily as a science building with the second story used by the literary societies for their halls and libraries. This structure, built in 1878, was the first added to the campus after the Old College Building. It was later known as the Heck-Williams Library. The School of Law began here.

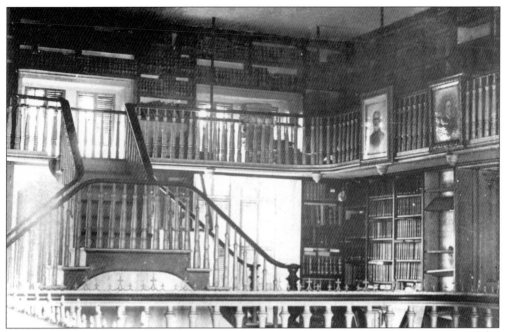

INTERIOR VIEW OF THE HECK-WILLIAMS LIBRARY. The college library was started by the two literary societies, which donated their respective libraries to the college in 1879. Windows and lanterns once furnished light for the library, in addition to a chandelier from the Philomathesian Society.

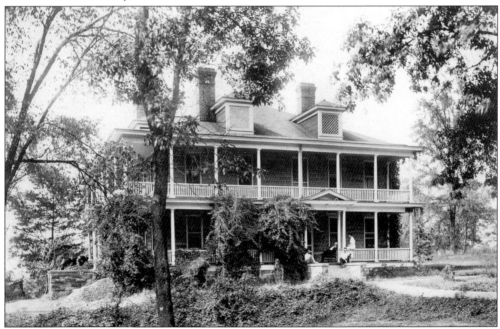

THE COLLEGE HOSPITAL. Opened in 1906, the College Hospital was located on the southwestern corner of the campus. It included patient rooms, a kitchen, dining room, operating room, and a ward for isolating contagious patients. It served both the college and the town. Medical students from the college interned in this facility.

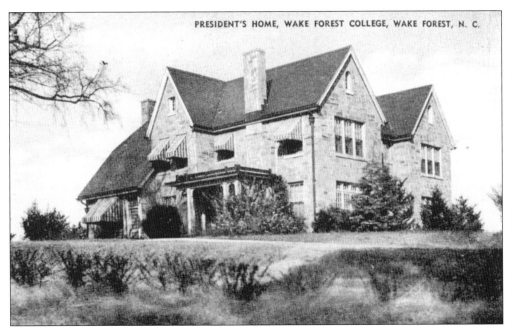

THE PRESIDENT'S HOME. The President's Home was built in 1928. Dr. Francis Gaines was the first president to occupy the house, which contained 12 rooms and was constructed at a cost of $22,500. Prior to President Gaines, the leaders of the school lived in houses of their own. President Samuel Wait's residence was the Calvin Jones House.

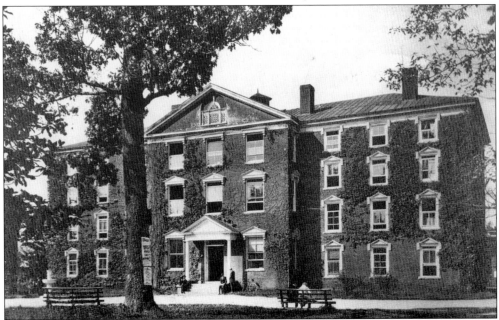

NEW WAIT HALL. Wait Hall was constructed on the site of the Old College Building (Old Wait Hall) following the 1933 fire. The new building was slightly larger but architecturally similar to the prior structure. It was used primarily for administrative functions, literary society meetings, and classrooms. Today it serves as Southeastern Baptist Theological Seminary's main administrative building.

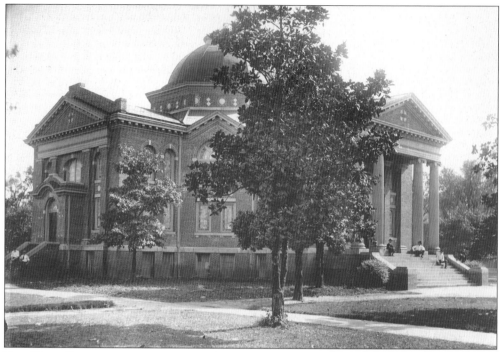

THE WAKE FOREST BAPTIST CHURCH. This congregation originally worshiped in the Old College Building and later in various locations on the campus. Dr. W.N. Johnson, a pastor of the church, led the movement to construct a separate building for the church. The church opened just in time to host a meeting of the Baptist State Convention in 1914. Today it boasts a very active congregation.

THE SIMMONS DORMITORY. The Simmons Dormitory was constructed in 1936 to house 100 students. During World War II, the Army Finance School occupied the building. Following the war, it housed five of the college fraternities.

CAMPUS VIEW, LOOKING EAST ALONG THE STONE WALL. President Charles E. Taylor is credited with a large number of campus beautification projects, including the stone wall, the campus paths, and the planting of more than 300 trees and more than 1,000 shrubs and vines. In 1885, the campus was expanded substantially, and the construction of the stone wall was initiated. This project was carried out by long-time campus personality "Dr. Tom" Jeffries. Upon its completion many years later, the wall circled more than 25 acres.

THE OLD OAKS. In the early days of the college, many old oaks graced the campus. These majestic trees were depicted in many early postcards and photographs. By Dr. Taylor's tenure as president (1884–1905), many of these trees were failing. By 1943, only 11 of the old oaks remained. A cross-section from the last standing original oak is on display at the Wake Forest Birthplace Museum.

Campus Walk. The campus walkways were installed along the footpaths worn by the students. The hundreds of flowers and shrubs along the campus walkways kept them in perpetual color.

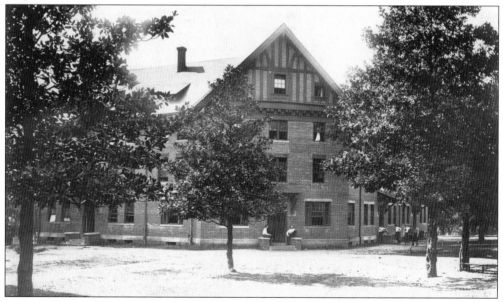

The Hunter Dormitory. Originally called New Dormitory and later renamed Hunter Hall, this building opened in 1914. It provided space for 75 students, and its basement housed the college's first heating plant. This building was constructed at the urging of Dr. Poteat, who felt the lack of dormitory space was detrimental to the growth of the college. Most students, and many faculty members, were living in private homes, a practice that remained popular until the college moved in 1956.

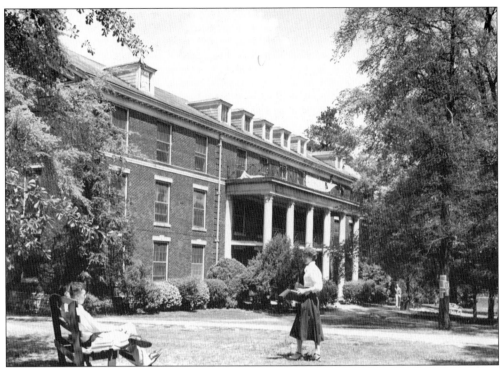

BOSTWICK DORMITORY. This dormitory was built to house 114 students and opened in 1924. The building was named for Jabez A. Bostwick, whose estate provided the majority of the funds to construct the building. Bostwick Dormitory was later used to house women, who were first admitted to the college in 1942 to make up for the decreased enrollment caused by World War II.

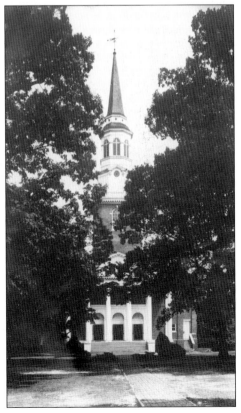

THE NEW CHAPEL. Following the burning of Wingate Memorial Hall in 1934, the college was without a chapel large enough to house the entire college community. During the first 100 years of its existence, mandatory daily chapel was an integral part of student life. Until the late 1960s, chapel service remained mandatory although it had been reduced to two or three times per week. The automobile—and the freedom it provided students—hastened the demise of mandatory chapel services. The new chapel opened in 1943. Students returning from World War II were housed in bunks in the basement.

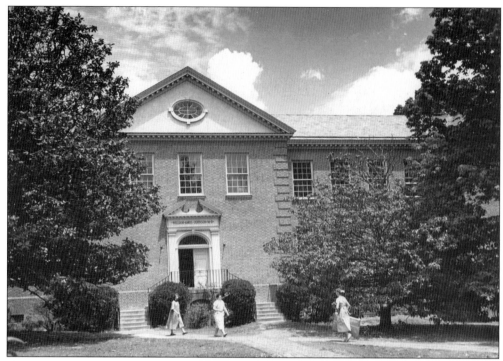

THE WILLIAM AMOS JOHNSON MEDICAL BUILDING. Opened in 1933, this building became home to the growing medical school. It was named for Dr. William Amos Johnson, a medical school faculty member killed in an automobile accident. Following the move of the medical school to Winston-Salem in 1941, the building was used for other purposes, including the home of the T.J. Simmons Art Collection.

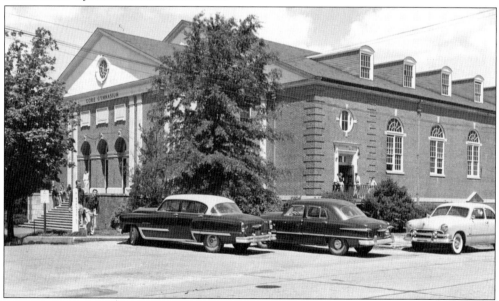

THE GORE GYMNASIUM. Opened in 1935, the new gymnasium allowed the college to meet the increasing space demands of intercollegiate and intramural indoor sports programs. It was named after alumnus Claude Gore.

THE COLLEGE CAFETERIA. Prior to the advent of on-campus dining facilities, students often ate in private homes and boarding houses in the community. "Miss Jo" Williams operated a dining facility for students for many years. She was given permission to construct an on-campus dining facility in 1938. Several other privately owned eating facilities operated in town to serve students and staff. During the war, this facility was used to feed soldiers attending the Army Finance School.

GORE ATHLETIC FIELD. Mr. Claude Gore, an alumnus with a special interest in athletics, provided the funds for the construction of the first dedicated athletic field. When completed in 1921, the field was considered one of the finest in the state. It was designed to provide adequate space for football, baseball, and track, and included two football fields. The field was named in Mr. Gore's honor, as was the 1935 gymnasium.

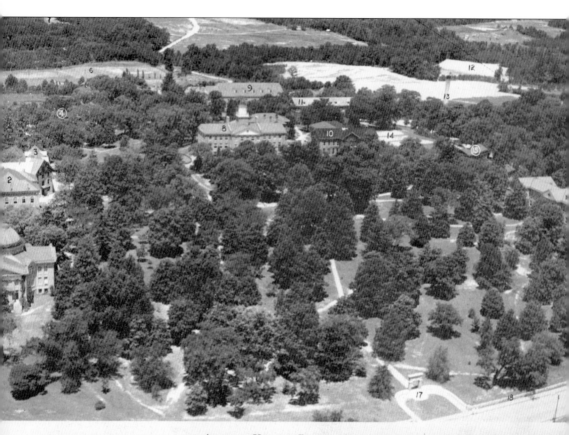

AIRPLANE VIEW OF GROUNDS, 1941

Church; 2. Alumni Building; 3. Hunter Dormitory; 4. Hospital; 5. Formerly Gore Athletic Field; 6. Groves Athletic
f Links; 8. Administration Building, with Old Gymnasium in rear; 9. Gore Gymnasium; 10. Heck-Williams Building; 11.
Dormitory; 12. Groves Stadium; 13. Heating Plant; 14. Tennis Courts; 15. Lea Chemistry Laboratory; 16. William
on Building; 17. Entrance; 18. Campus Wall.

AERIAL VIEW OF THE GROUNDS IN 1941. Originally the college owned more than 600 acres of
land, but over the years much of this land was sold to raise money for the school. By 1900,
the college owned very little land except for the campus and six acres of athletic fields
nearby. In 1915, the college purchased 155 acres north of town from the Walters family.
Later, in 1930, an additional 52 to 55 acres north of the Walters property was acquired. An
additional 40 acres were acquired in 1939 and 1940 to construct the football stadium. The
campus consisted of approximately 450 acres by the 1940s.

Two
LIFE ON THE
OLD CAMPUS

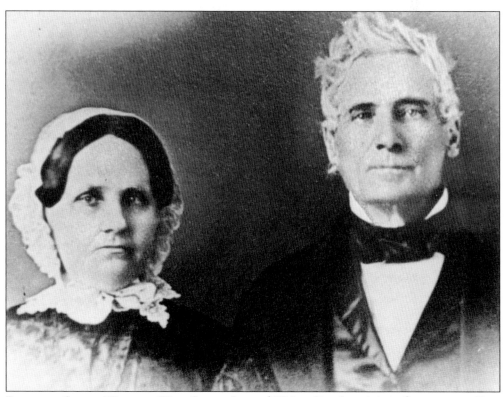

PRESIDENT SAMUEL WAIT AND WIFE, SARAH. Samuel Wait, a Baptist minister from upstate New York, was instrumental in the founding of Wake Forest and served as its first president from 1839 to 1845. During the early years of the college, he was often away from the campus. He deserves much of the credit for nurturing the college through the many difficulties faced in establishing an academic program, fund-raising, and developing a vision for the school.

COLLEGE PRANK. The background of this bovine prank is lost to history, but students have always found a way to amuse themselves. Another student amusement was to sneak into the Old College Building and ring the college bell at midnight without being apprehended. The bell was later rung by students following athletic victories.

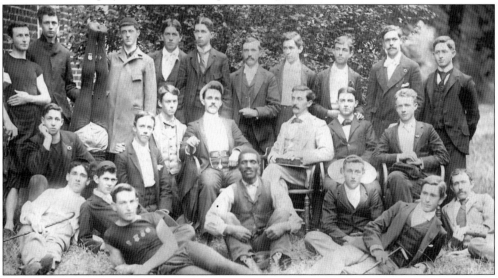

STUDENT GROUP WITH "DR. TOM" JEFFRIES. The son of slaves who moved to North Carolina following the Civil War, Tom Jeffries is one of the more colorful characters in the history of Wake Forest. He worked for the college during the entire administrations of both Presidents Taylor and Poteat: a span of 43 years. He would now be described as a multi-skilled worker. His duties included ringing the bell, performing maintenance of buildings, constructing the stone wall surrounding the campus, planting trees and shrubs on the campus, and attending to anything else that needed to be done. His keen sense of humor and oratorical skills made him a great favorite with both students and faculty. On one occasion while Tom was burning some grass, a freshman was said to have remarked to him, "It is almost as black as you are, Tom." Tom immediately responded, "Yes sir, yes sir, and next spring it'll almost be as green as you are."

PRESIDENTS CHARLES E. TAYLOR AND WILLIAM LOUIS POTEAT. Dr. Charles Taylor was president of Wake Forest from 1884 to 1905. President Poteat led the college from 1905 to 1927. President Taylor guided Wake Forest through many years of growth in campus facilities, curriculum, and enrollment. During his tenure, both the medical and law schools were founded. President Poteat, a Wake Forest graduate, began teaching evolution early in his career as a biology professor. This liberal position subjected him to great criticism in some Baptist circles. His administration was marked by continued growth in enrollment as well as the strengthening of the college's financial standing. Both men were devout Baptists.

THE PHILOMATHESIAN LITERARY SOCIETY MEETING ROOM IN 1887. The Philomathesian and Euzelian Literary Societies had a tremendous impact on the lives of the students and faculty until the 1920s. Originally, all students were required to join one of the two literary societies. It was in these meeting rooms in the Old College Building that members would engage in debate and make literary presentations. Topics of national interest, including slavery and secession, were enthusiastically debated in great detail in the 1850s and 1860s.

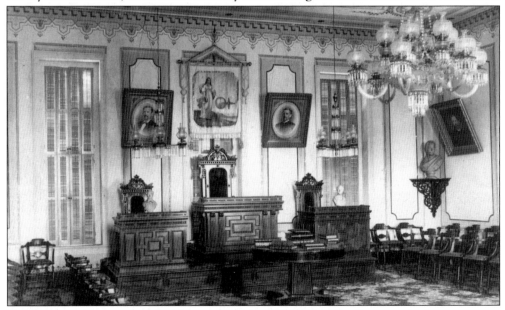

THE EUZELIAN LITERARY SOCIETY MEETING ROOM IN 1887. The Euzelians met in the west room in the Old College Building, while the Philomathesians met in the east room. The literary societies were very interested in the appearance of their meeting rooms and invested much time and money in procuring furniture, banners, carpet, and appropriate lighting for the facilities. Many of the special chairs used in these rooms survive today.

FACULTY OF 1885. The faculty of 1885 is pictured in this photograph. A fully-bearded President Taylor is in the center.

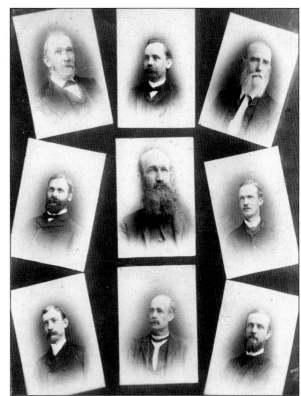

CLASS OF 1875. The graduating Class of 1875 consisted of only 9 students.

FIRST FEMALE GRADUATE OF WAKE FOREST. Although women were not officially admitted to Wake Forest until 1942, the daughters of faculty and staff were allowed to attend classes. The first woman to graduate from the college was Miss Eva Belle Simmons, who graduated in 1890 with special permission of the trustees. She was the daughter of William Gaston Simmons, a professor of natural science at Wake Forest for 35 years. Her brother, Thomas J. Simmons, became president of Brenau College and donated his sizeable art collection to Wake Forest in 1940. Eva Belle is pictured here with the graduating Class of 1888.

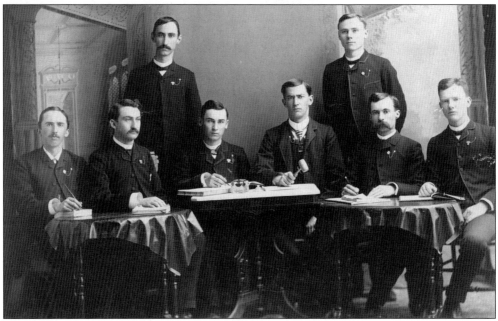

THE DEBATE TEAM OF 1886. The first intercollegiate debate at Wake Forest was held in 1897. The right to represent the college was earned by winning a series of preliminary events. Hundreds of spectators attended the early debates, and it was sometimes difficult to find space to house the large crowds. President Poteat was often personally involved in the selection of participants to represent the school.

STUDENT GATHERING. Students pose for a picture between Old Wait Hall and the library around the turn of the century.

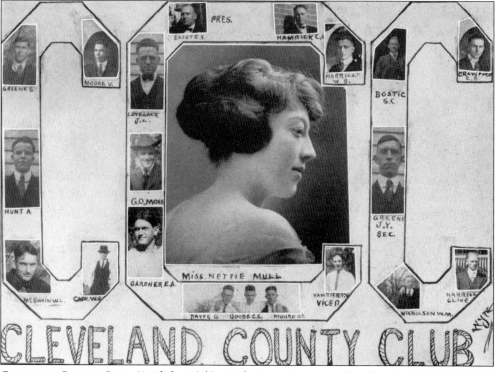

CLEVELAND COUNTY CLUB. Until the 1940s, Wake Forest remained a school populated almost entirely by students from North Carolina. Clubs, like this one from 1922, reflected the small town nature of most of the students.

31

DUM VIVIMUS LUDAMUS. The members of this organization pose in 1904. Known as the DVL, this student organization was the source of much controversy. For many years, the college forbade the existence of any campus societies other than the literary ones. The DVL claimed its members were not a society but a social club. The existence of this organization on campus led to the formation of other social groups. The controversy continued for many years. In 1904, the college implemented a one-year trial for fraternities. During the trial year, competition with the literary societies was fierce, and in 1905 the college once again outlawed fraternities on campus. In 1922, the faculty voted to make membership in the literary societies optional and legalized fraternities.

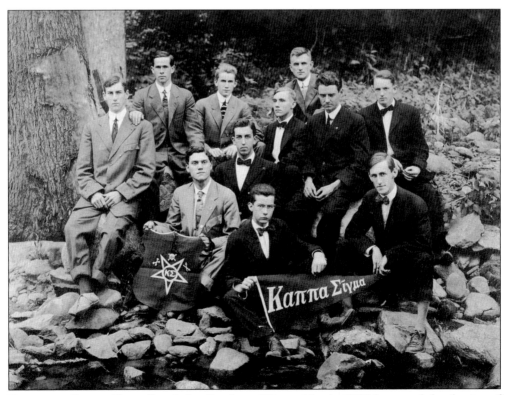

FRATERNITY GROUP. The college's legalization of fraternities in 1922 hastened the demise of the literary societies and started the development of the current Greek system on campus.

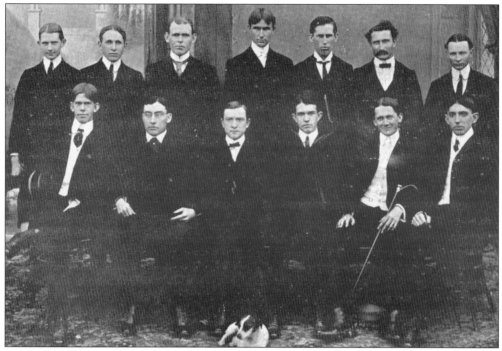

LAW STUDENTS FROM 1903. The law school at Wake Forest first registered students in the summer of 1894. Discussions regarding the establishment of a law school at Wake Forest were held as early as 1879. The law school quickly developed a strong reputation in North Carolina and, in less than 10 years, more than 40 percent of all of the lawyers who passed the state bar examination were graduates of the program.

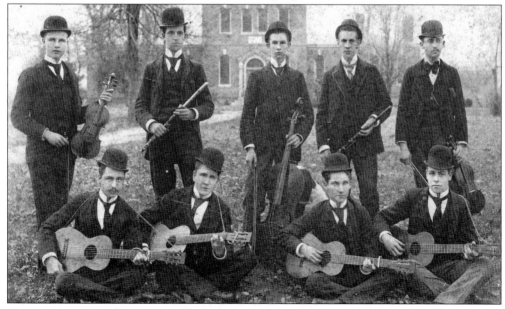

ORCHESTRA, c. 1894. In the college's first years, students sometimes met with President Samuel Wait on Saturday afternoon to play musical instruments. Social life often revolved around campus groups and activities.

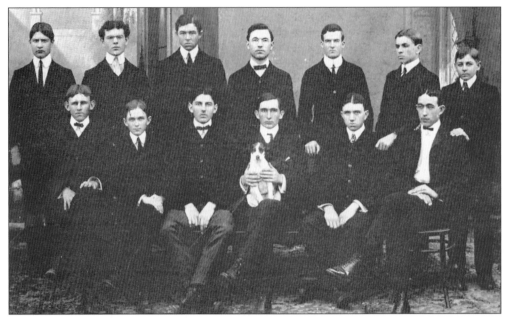

MEDICAL STUDENTS FROM 1903. Wake Forest's two-year medical training program opened in the fall of 1902. In June of 1941, with the help of the Bowman Gray Foundation, the medical school relocated to Winston-Salem and converted into a four-year program. On the occasion of its centennial birthday in 2002, the medical school published a photographic history, *Legacy & Promise, One Hundred Years of Medicine.*

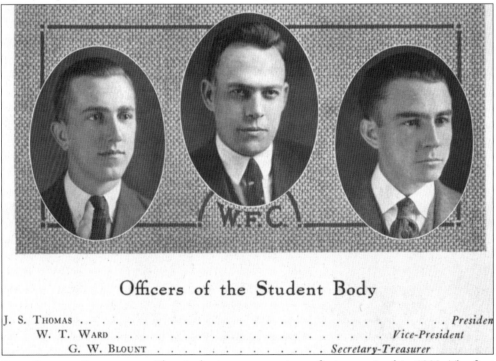

Officers of the Student Body

J. S. THOMAS . *Presiden*
 W. T. WARD . *Vice-President*
 G. W. BLOUNT . *Secretary-Treasurer*

FIRST STUDENT GOVERNMENT. The student government was first organized in 1923. The first officers appear in this photograph.

THE QUILL CLUB. This picture of the Quill Club of 1922 features a young Dr. Hubert Poteat (top row, left), who would become a long-time fixture on campus. The college publications have garnered dozens of awards over the years, and many alumni have gone on to successful careers in journalism and publishing.

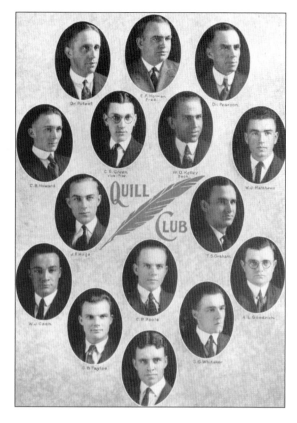

COLLEGE BAND. The band is pictured here in 1927.

THE STUDENT. The editors of *The Student* appear in this 1898 photograph. The literary magazine was started in 1882 and was the first printed student publication. *The Student*, which was supported by both literary societies, covered topics of local, state, national, and international interest. The magazine included student and faculty writings.

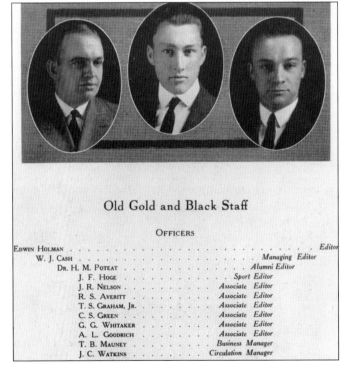

Old Gold and Black Staff

OFFICERS

EDWIN HOLMAN	Editor
W. J. CASH	Managing Editor
DR. H. M. POTEAT	Alumni Editor
J. F. HOGE	Sport Editor
J. R. NELSON	Associate Editor
R. S. AVERITT	Associate Editor
T. S. GRAHAM, JR.	Associate Editor
C. S. GREEN	Associate Editor
G. G. WHITAKER	Associate Editor
A. L. GOODRICH	Associate Editor
T. B. MAUNEY	Business Manager
J. C. WATKINS	Circulation Manager

OLD GOLD AND BLACK. The student newspaper, *Old Gold and Black*, first appeared in 1916. This view of the editorial staff from 1922 included young W.J. Cash (right), whose later book *The Mind of the South* is considered one of the most significant books ever written about southern culture.

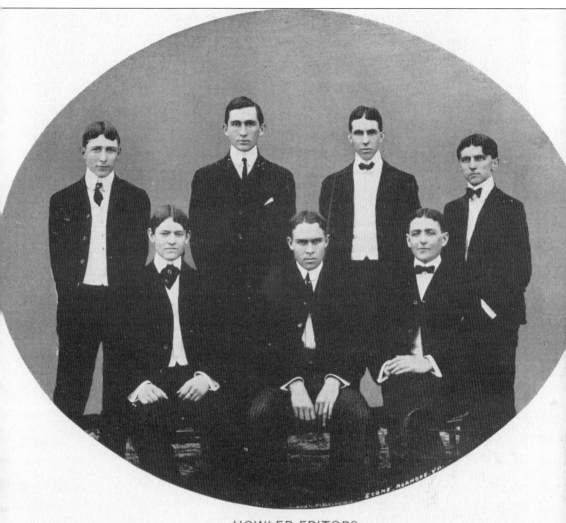

HOWLER EDITORS

EDWIN J. SHERWOOD, Business Manager ROBERT G. CAMP, Editor-in-Chief

ASSOCIATES

HN A. McMILLAN WILLIAM H. PACE CHARLES P. WEAVER H. PAUL SCARBOR

BURTON J. RAY, Art Editor

THE HOWLER. The Howler, the college annual, first appeared in 1903. The annual's name derives from a large tree that was located on the old campus where students, faculty, and townspeople would post announcements and other news. Posting events on the tree was the most effective way to "howl out the news."

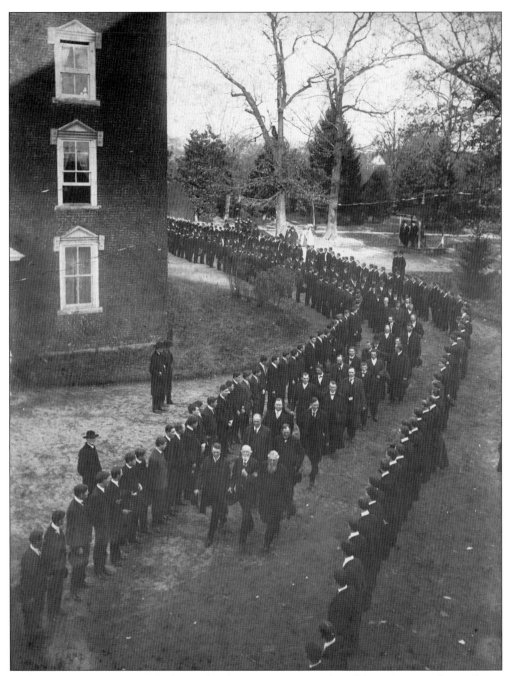

ACADEMIC PROCESSION. An early academic procession on the old campus is shown here. Continuing a tradition that started prior to the Civil War, the faculty and trustees marched to the ceremony with the graduating students. Caps and gowns were not introduced until 1912.

THE ADMISSION OF WOMEN. The decision by the United States to enter World War II dramatically reduced the number of men available to attend college. In order to survive, many colleges began admitting women in the early 1940s. Coeds Carolyn Vick, Marina Hawkins, Viola Hopkins, and Lois Bradley are shown in the first coed residence on Faculty Avenue.

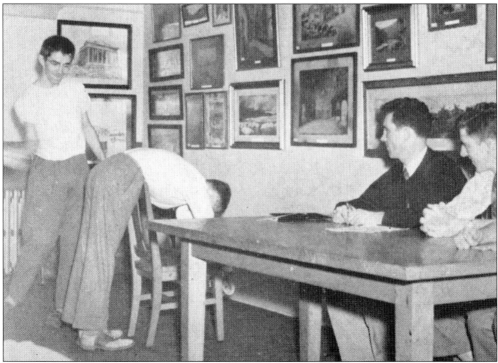

HAZING ON CAMPUS. Admission into the literary societies, fraternities, and other social groups often involved hazing rituals. These practices continued well into the 1940s and 1950s. In this 1943 picture, a freshman is paddled.

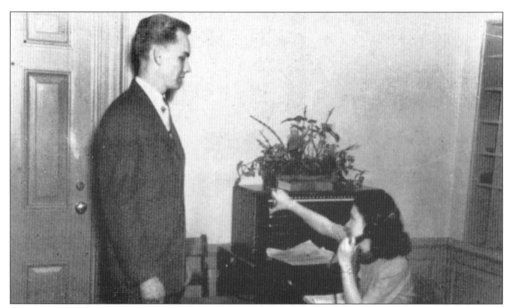

DATING ON CAMPUS. A student waits while the receptionist calls his date. Curfews were early and strictly enforced.

WOMEN'S GLEE CLUB. The decision to admit women in 1942 led to the development of a host of cultural, academic, athletic, and social organizations for women at the college.

DRAMATIC PRODUCTIONS. Primarily because there were no women students prior to 1942, no college-sponsored dramatic productions were held on campus during the first 100 years of the college's existence. Students founded the Little Theatre group and produced four plays each season beginning in 1942. Here two cast members perform in the 1942 production of *You Can't Take It With You*.

GLEE CLUB. The 1939–1940 College Glee Club is shown here. The WFC insignia visible on the terra cotta floor of Wait Hall is a treasured symbol of the old campus.

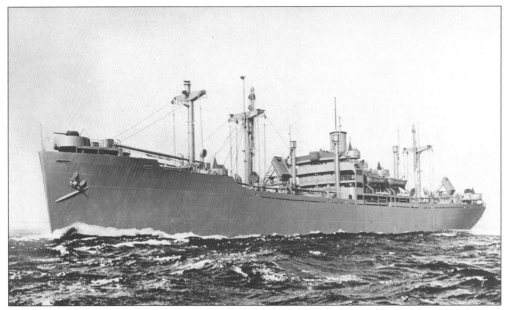

WAKE FOREST VICTORY. World War II had a tremendous impact on the college community. Thousands of alumni and students served in various branches of the armed forces. During the war, the Army Finance School operated on campus. Approximately 70 students and alumni were killed in the war. On March 31, 1945, the S.S. *Wake Forest Victory*, a cargo ship, was commissioned and placed into service.

COLLEGE BAND. The 1948 marching band poses in the "WF Formation."

COLLEGE CHOIR. Shown here is the College Choir of 1950.

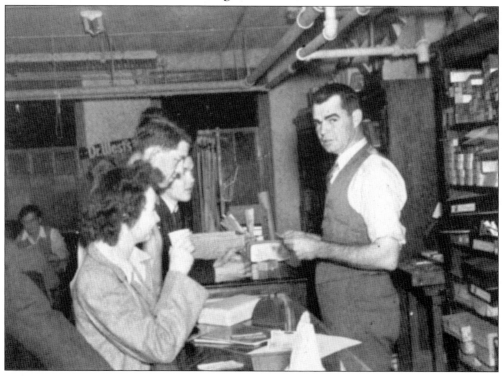

COLLEGE BOOKSTORE. Everette Snyder helps customers in the college bookstore. Located in the basement of the Social Sciences Building, this small store sold textbooks and other college essentials.

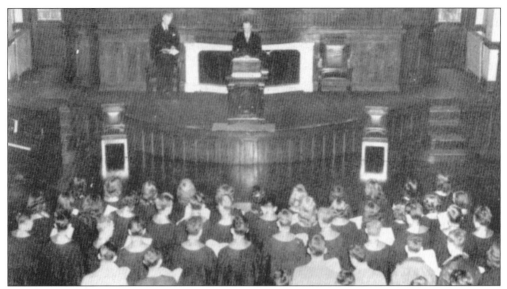

MANDATORY CHAPEL SERVICES. Students often used great creativity to find ways to avoid mandatory chapel, and practical jokes were not uncommon. On one occasion, students herded several chickens into the service. In another infamous event, students lowered a large bra from a string behind the featured speaker. Mandatory chapel continued on the Winston-Salem campus until 1968.

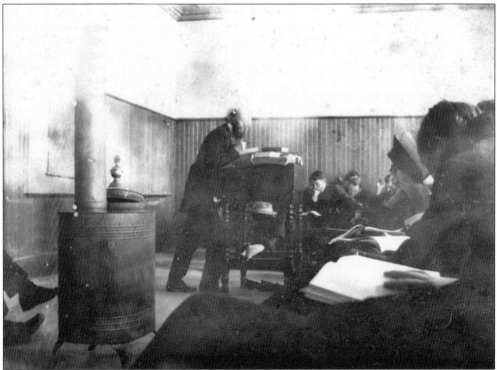

CLASS LECTURE. Benjamin "Slick" Sledd lectures to a class. Attending college in the 19th and early 20th century often meant sitting in hot or cold classrooms that were poorly lit. Note the large woodstove in the foreground.

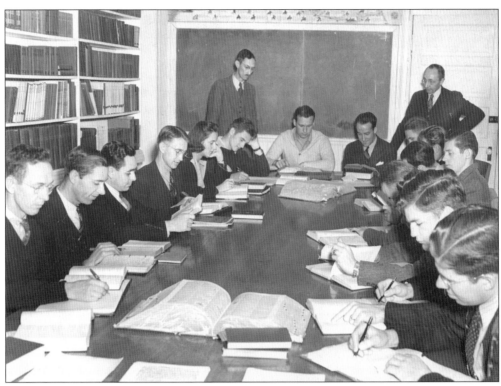

ENGLISH SEMINAR. Professors Edgar E. Folk and H. Broadus Jones lead an English seminar. Since its earliest years, a characteristic of a Wake Forest education has been small classes with close interaction between students and faculty.

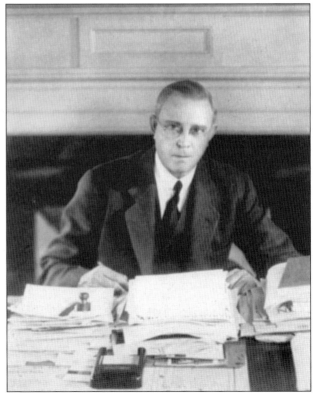

PRESIDENT THURMAN D. KITCHIN. Thurman D. Kitchin became president of Wake Forest in 1930 and served his alma mater for 20 years. Under his leadership, undergraduate enrollment increased from 700 students to more than 2,000. The faculty expanded from 46 members in 1930 to more than 187 in 1950. Additionally, eight new buildings were added to the campus. Dr. Kitchin is also credited with increasing the quality of the academic programs at the college.

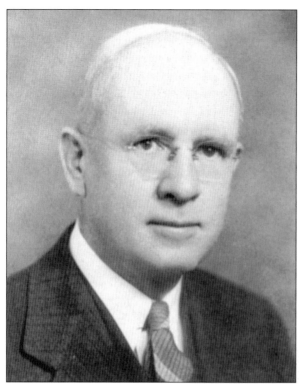

BURSAR E.B. EARNSHAW. An excellent athlete in his college days at Wake Forest, E.B. Earnshaw married the youngest daughter of President Charles E. Taylor. Following their marriage, they both began a lifetime of service to the college. Mr. Earnshaw served as Bursar from 1907 until his death in 1952.

DEAN D.B. BRYAN. D.B. Bryan served Wake Forest as dean of the college from 1923 until 1957. President Tribble convinced Dean Bryan to come to Winston-Salem to assist in the organization of the new campus.

DEAN LOIS JOHNSON. "Miss Lois" was appointed dean of women after women were first admitted to the college in 1942. An extensive list of rules governed the behavior of coeds. Curfew was 10:30 during the week and 11:30 on the weekends. Women could not ride in cars or airplanes without the permission of their parents, and they could not smoke on the streets. Women were forbidden to enter any man's room and could not drink alcohol. They were also required to wear raincoats over their shorts on the way to gym class. Dean Johnson served as the dean of women for 20 years. An elegant woman, Miss Lois was extremely popular with the female students on campus.

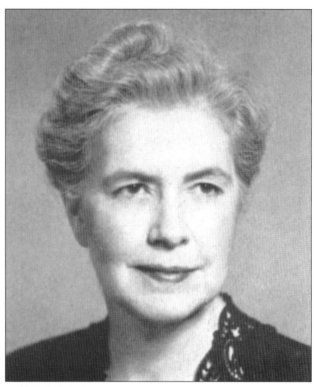

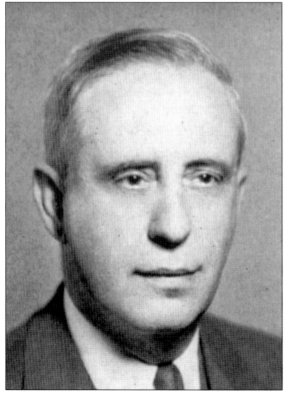

DR. HUBERT M. POTEAT. The son of Wake Forest President William Louis Poteat, "Dr. Hubert" or "Old Thunder" as he was known, served as professor of Latin from 1912 to 1956. He had previously served on the faculty of Columbia University and was known as the leading intellectual on campus. Respected by everyone, he was physically imposing and possessed a booming voice. Poteat did not make the move to Winston-Salem.

DR. WILLIAM E. SPEAS. "Bill" Speas was a professor of physics who was notorious for talking to himself. He was known for "a boyish enthusiasm for physics experiments, even those that he had seen a hundred times before."

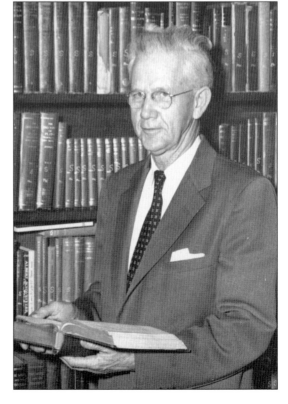

DR. A.C. REID. Dr. Reid was a very popular professor of philosophy. He had several idiosyncrasies that students loved to imitate. He usually whistled when he pronounced the letter "s," and he generally locked his door at the beginning of class, refusing to admit tardy students. In discussing the college's move to Winston-Salem, he is said to have remarked, "When a man carves a home out of a wilderness, he is not prone to move anywhere." In the end, his commitment to the school proved too great, and he commuted from his home in Wake Forest to teach on the campus in Winston-Salem.

48

DR. C.C. PEARSON. "Skinny" Pearson was a teacher of history and government. Students found him both "endearing and formidable." He served Wake Forest from 1916 to 1952. At his retirement dinner, it was remarked that students would remember him for "his characteristic jokes and intriguing quiz questions, but also as an eminent scholar, able teacher, and fair-minded gentleman."

ONE OF THE LAST COMMENCEMENTS HELD ON OLD CAMPUS. In this 1950s commencement photograph, the seniors prepare for their final walk across the campus as undergraduates.

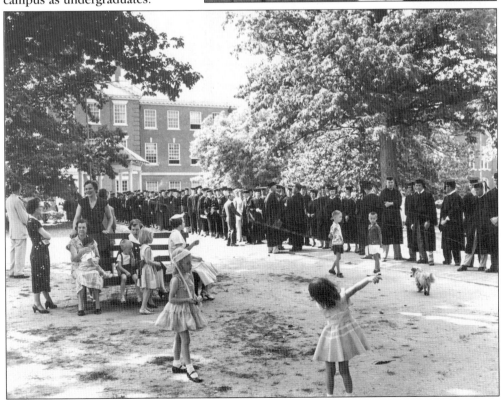

Dr. Harold W. Tribble. Dr. Tribble was inaugurated as president of Wake Forest in 1950 and served until 1967. The Herculean task of planning and building a new campus in Winston-Salem, while continuing to operate the college, fell upon his shoulders. The decision to relocate the campus was not popular in all circles, and Dr. Tribble survived at least one attempt to remove him from office. During Dr. Tribble's tenure, more than $30 million dollars was raised for Wake Forest, the first black students were admitted, and graduate studies were resumed. Student enrollment grew to over 3,000. A man of great resolve, Dr. Tribble navigated many difficult problems, including the increasingly complicated issues surrounding the relationship with the State Baptist Convention. Realizing a goal proposed by Dr. Tribble in his inauguration speech, the college trustees announced that Wake Forest would become a university in the fall of 1967.

Three
THE TOWN OF WAKE FOREST

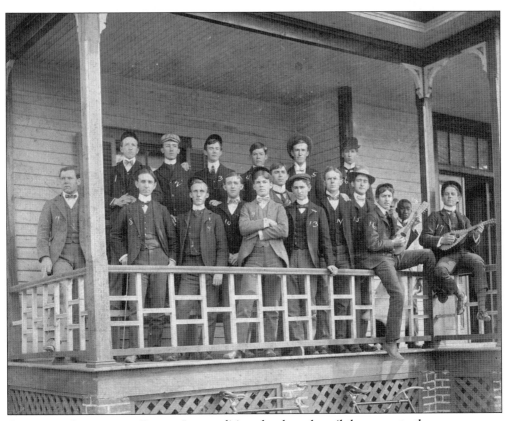

PICTURE OF STUDENTS ON PORCH. In a tradition that lasted until the move to the new campus in 1956, many students lived in private homes in the area. This fostered very close relationships between the townspeople and the college.

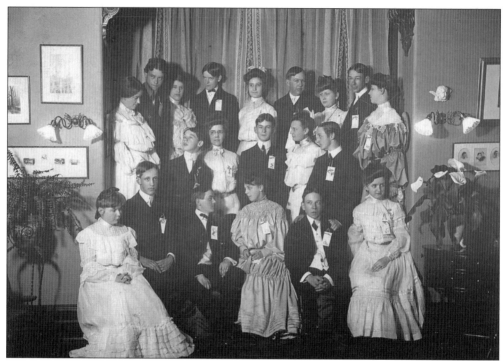

VIEW OF STUDENTS WITH DATES IN ROOMING HOUSE. Students and their friends pose for this picture in a private home or rooming house in Wake Forest.

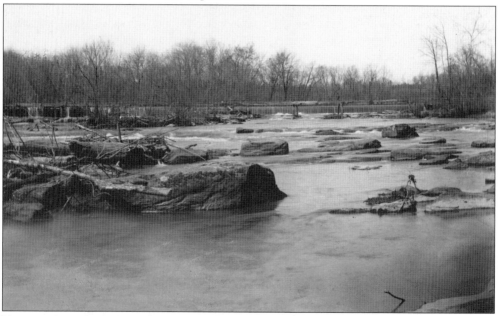

THE NEUSE RIVER C. 1890. This view of the Neuse River was made from a glass negative dating from 1890. The photograph was likely taken by Wake Forest President Charles Taylor. A collection of family glass negatives is in the possession of the Wake Forest Birthplace Society. The Neuse River was a popular recreation spot for students and residents of the town. (Courtesy Wake Forest Birthplace Society.)

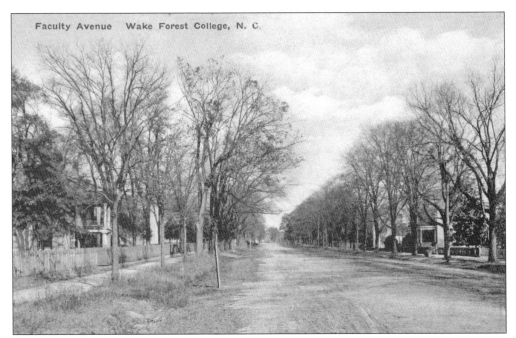

FACULTY AVENUE. This photograph of an unpaved Faculty Avenue dates from the turn of the century. The streets in Wake Forest were paved in the 1920s. (Courtesy Wake Forest Birthplace Society.)

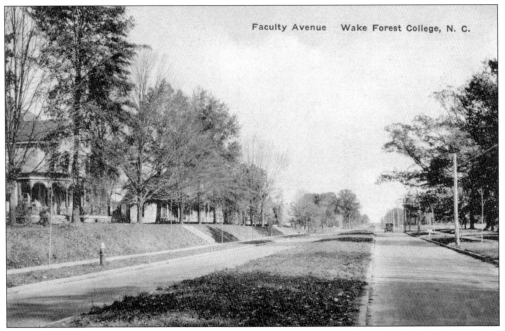

A 1920s POSTCARD VIEW OF FACULTY AVENUE. This road was part of U.S. Highway 1 that ran from Florida to Maine. In 1892, Dr. Charles Brewer, professor of chemistry at Wake Forest and later president of Meredith College, built the house on the far left. (Courtesy Wake Forest Birthplace Society).

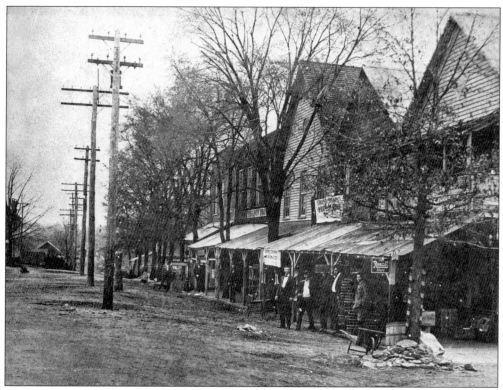

WHITE STREET. White Street is the main business street in Wake Forest. This street view was taken a few years after electrical service was introduced in 1909. T.E. Holding Drugs was established in 1888 and can be seen on the right. (Courtesy Wake Forest Birthplace Society.)

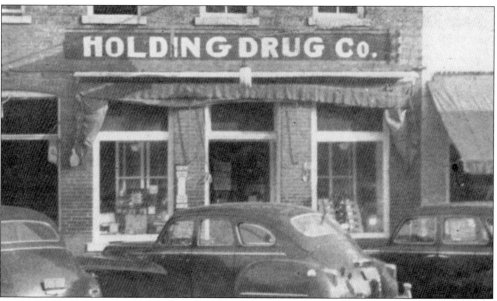

HOLDING DRUG COMPANY, 1948. The Holding Drug Store is pictured as it appeared in 1948.

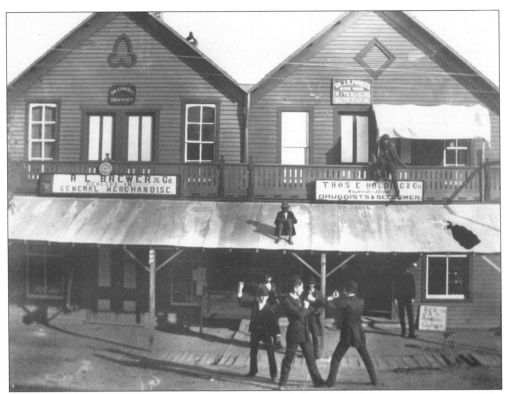

A.L. Brewer & Co. and T.E. Holding & Co. Mr. Brewer's store was a familiar landmark for everyone in the community. An old-fashioned general store, it sold feed, grain, and other commodities. T.E. Holding & Co. later became Holdings Drug and Soda Shop and was a popular lunch establishment. This early view dates from 1915. (Courtesy Wake Forest Historic Preservation Commission.)

Powers Drug Store. The Powers Drug Store was established in the 1880s by Dr. John B. Powers and later operated by his son, Bruce. It stood beside the railroad tracks next to the Wake Forest Hotel. (Courtesy Wake Forest Birthplace Society.)

PUREFOY AND REID GENERAL STORE. This general store on White Street is pictured *c.* 1900. (Courtesy Wake Forest Birthplace Society.)

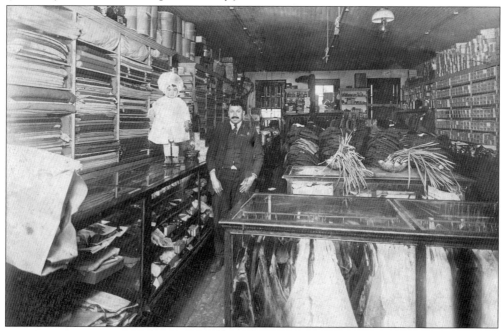

BOLUS CLOTHING STORE. Mr. George Bolus, a Lebanese immigrant, opened a clothing store in Wake Forest in 1908. This view of the interior of his store dates from *c.* 1920. Prior to opening his store, he traveled from his home in Raleigh selling his goods from the back of a horse-drawn wagon. (Courtesy Wake Forest Birthplace Society.)

MR. TOM ARRINGTON AS A YOUNG CHILD. Tom Arrington, Wake Forest Class of 1939, is pictured here with an older man, perhaps his grandfather. Tom was the great-great-great-great-grandson of Samuel Wait, the first president of Wake Forest College. The Wake Forest Birthplace Society houses his family collection of photographs and postcards. (Courtesy Wake Forest Birthplace Society.)

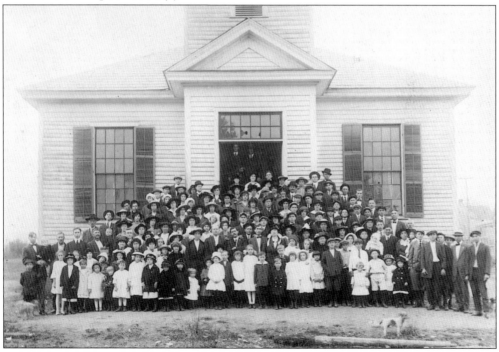

THE ROYALL BAPTIST CHURCH AND CONGREGATION. Construction of this church was started in 1901 and completed in 1902. It is located on the corner of Mill and First Streets in the Glen Royall Cotton Mill Village. (Courtesy Wake Forest Birthplace Society.)

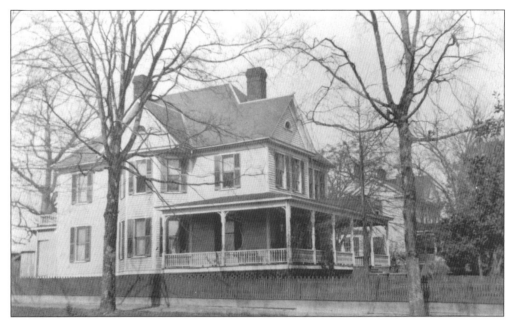

HOME OF DR. AND MRS. JOSEPH GORRELL. The Gorrell family constructed this Queen Anne–style residence between 1905 and 1910. Mrs. Fannie Gorrell was the daughter of Wake Forest President Charles Taylor. Her husband, J. Hendren Gorrell, was a professor of languages at the college. (Courtesy Wake Forest Historic Preservation Commission.)

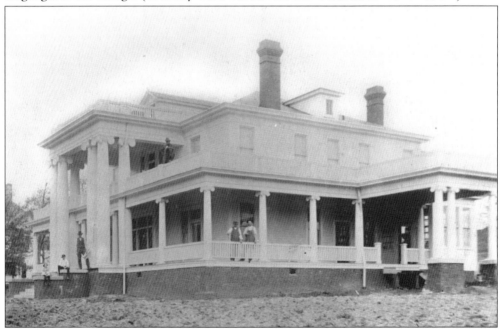

FIRST RESIDENCE FACILITY FOR WAKE FOREST COEDS. This large, Classical Revival–style home was completed in 1912. It was built for William Royall Powell, the son of William C. Powell, one of the founders of the Glen Royall Cotton Mill. It later housed the first 17 full-time women students at Wake Forest in 1942–1943. (Courtesy Wake Forest Historic Preservation Commission.)

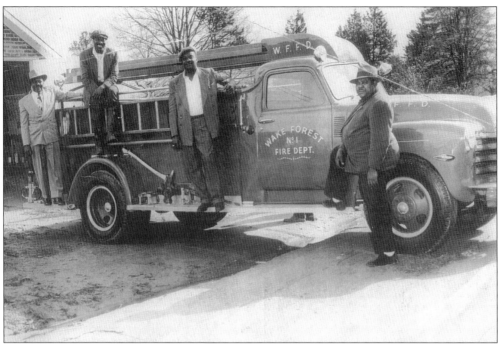

WAKE FOREST VOLUNTEER FIRE DEPARTMENT. The Wake Forest Volunteer Fire Department is pictured in 1940. Members, from left to right, are Chief Edward Alston, Matthew Williams, George Massenburg, and Robert Alston. (Courtesy Wake Forest Birthplace Society.)

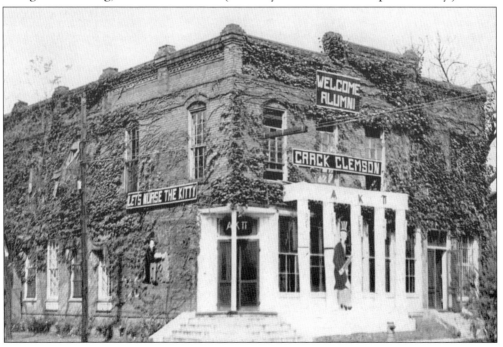

ALPHA KAPPA PI FRATERNITY HOUSE. This old building on Faculty Avenue has been used for many purposes. In 1943, it was the Alpha Kappa Pi fraternity house. Earlier, it was Mrs. Newsome's boarding house.

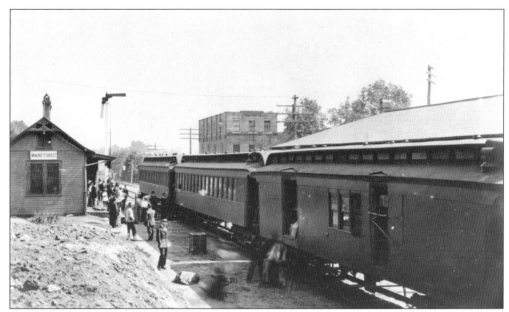

TRAIN STATION, *c.* 1890. The Wake Forest Passenger Depot is on the left and the Freight Depot is on the right. Prior to the initiation of train service to Wake Forest in 1874, the closest station was located in Forestville, approximately three miles from town. In the days before automobiles were plentiful, the college and townspeople were able to catch numerous trains of the Raleigh and Gaston Railroad into and out of Raleigh. (Courtesy Wake Forest Birthplace Society.)

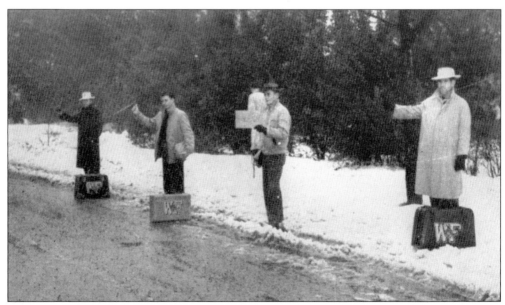

BUMMING CORNER. Few students could afford to own cars on the old campus, and hitchhiking to Raleigh, Durham, or more remote locations was routine. The hitchhiking corner was located on U.S. 1, across from the Wake Forest Baptist Church. Students try their luck on a cold, snowy day in 1948.

"Miss Jo" Williams's Boarding House. Miss Jo operated one of the more successful boarding houses in Wake Forest. It was not until the 1940s that the college opened its first dining facility on campus. Mrs. Harris and Mrs. Newsome also operated popular boarding houses in the community. Each of these establishments offered three high quality meals a day for a flat weekly fee. A boarding house would feed between 50 and 100 patrons per meal. Following World War II, the boarding system ended as new dining options appeared in the community and the college began offering food services on campus.

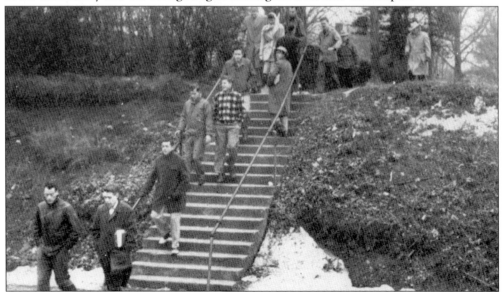

Staircase on the Way to the Railroad Tracks. The walk to town over the railroad tracks to eat, pick up mail, and shop was a daily routine for everyone in the college community.

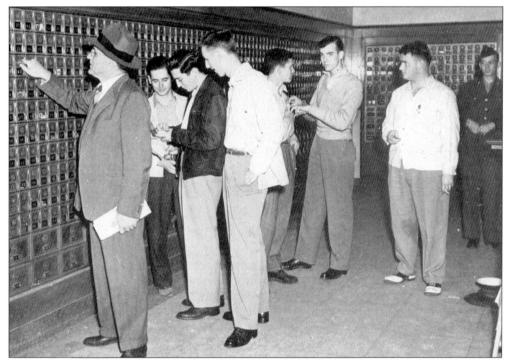

WAKE FOREST POST OFFICE. The first stop on a trip to town was usually the post office, as the college did not operate a separate mail facility. Lib Greason was a long-time fixture in the post office and knew everyone by name. She was the wife of Wake Forest basketball coach Murray Greason and the mother of Murray Greason Jr., the current chairman of the Board of Trustees of Wake Forest University.

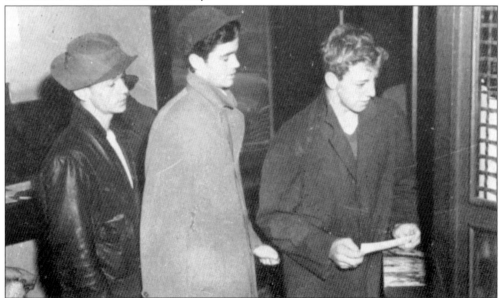

DURHAM BANK AND TRUST COMPANY. The only bank in Wake Forest for many years was the Wake Forest branch of the Durham Bank and Trust Company. Students in this photograph wait in line to cash checks. To many, this bank was known simply as Mr. Satterwhite's bank.

INTERIOR VIEW OF THE FOREST THEATRE. The Forest and Collegiate movie houses were located across the street from each other. Both were popular with the college community as well as the townspeople. The Forest Theatre was an older, more traditional theatre. The Collegiate backed up to the railroad tracks, and passing trains would cause the theatre to shake. Later, the Collegiate was damaged in a fire, and for a time, movies were shown in a tent until the damage could be repaired.

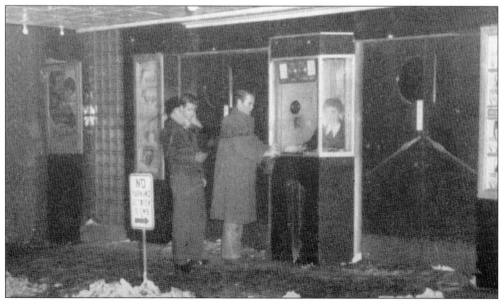

THE COLLEGIATE THEATRE. Students purchase tickets for a movie at the Collegiate in 1948.

SHORTY'S. Millard "Shorty" Joyner operated the most popular college hangout for students, Shorty's Hamburger Heaven. Shorty opened his restaurant in 1916, following a fire that destroyed a prior business that had been opened by his father in 1900. This business was a combination restaurant and pool hall. It was a tradition for students to congregate at Shorty's after returning from an evening in Raleigh or Durham. One former student remarked, "I don't think Shorty's ever closed, it was always open." At one time, everything at Shorty's cost a nickel. Alcohol was prohibited everywhere in Wake Forest, but it was rumored that Buster, one of Shorty's employees, could provide students with alcohol for the right price.

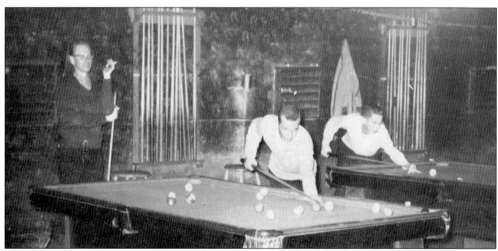

POOL HALLS. Pool was a popular pastime with students. Tom's Pool Room, Brown's Pool Room, Francis Grill, and Shorty's were favorites with students looking to relax.

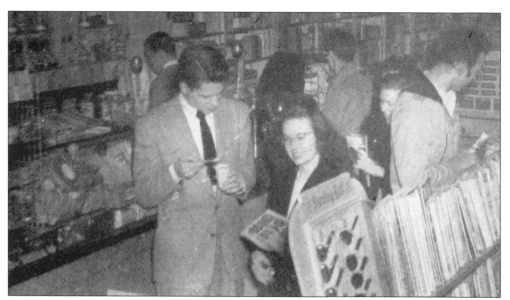

INTERIOR OF EDWARDS PHARMACY. Two students eat and browse inside Edwards Pharmacy.

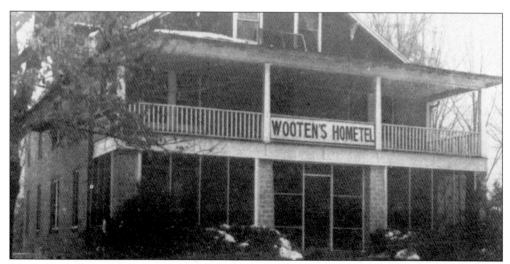

WOOTEN'S HOMETEL. Wooten's was a popular tourist home where travelers could rent rooms and enjoy a good meal. Many postcards of this home exist. The restaurant in the basement was a popular establishment for the residents of Wake Forest.

COLLEGE SODA SHOP. Another popular stop for students was at the College Soda Shop, also known as "P.D.'s" for the proprietor P.D. Weston. Waffles were the specialty of the house. Many in the college community knew employees Fred, Ben, and Smut.

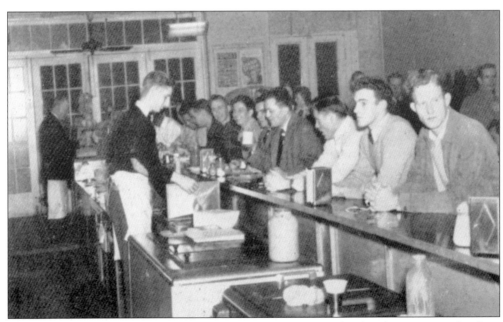

COUNTER AT PEYTON BROWN'S. This restaurant was known for hamburgers, sandwiches, and coffee.

FRANCIS GRILL. Students catch up in Francis Grill in 1955.

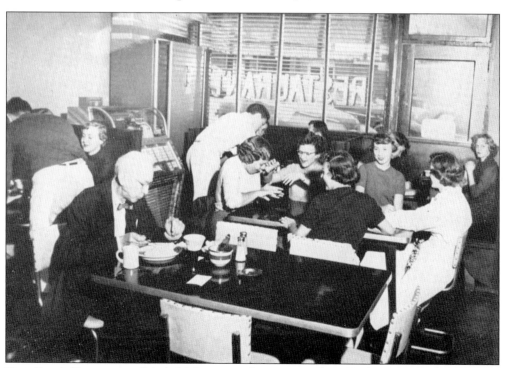

DICK FRYE'S RESTAURANT. Fried chicken was a house specialty at Dick Frye's. Professor Edgar Timberlake Jr. is seated at left.

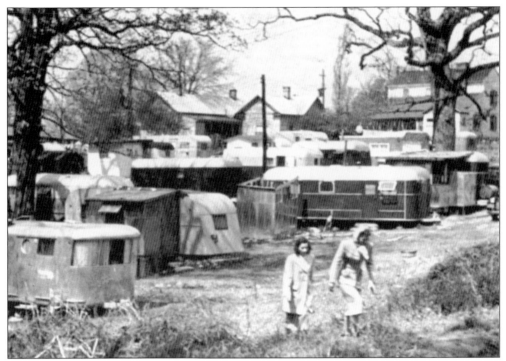

TRAILER PARK. Following the end of World War II, the large number of returning soldiers led to a campus housing shortage. To accommodate the demand, several large trailer parks were established.

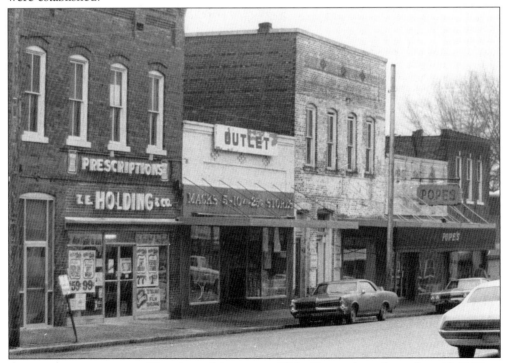

DOWNTOWN WAKE FOREST. This view of downtown Wake Forest dates from the mid-1960s.

Four

THE MOVE TO WINSTON-SALEM AND THE NEW CAMPUS

DR. TRIBBLE AND ODUS MULL
COMMEMORATING THE MOVE OF THE
COLLEGE. The future of the college
was changed in dramatic fashion in
1946 when the Z. Smith Reynolds
Foundation announced an annual
gift of $350,000 in perpetuity if the
college would relocate 110 miles
west to Winston-Salem. The town
of Wake Forest literally had grown
up around the college. When the
move to Winston-Salem was
announced, the student newspaper
concluded in an editorial, "The
town of Wake Forest has a
sympathetic feeling for the town of
Hiroshima. . . . The little town,
which has contributed more than
$100,000 to the enlargement
campaign and in which most of the
citizens are bound by close
personal ties to the college, could
not have been more dumbfounded
and aghast if foreign planes had
dropped a bomb in the center of
the village."

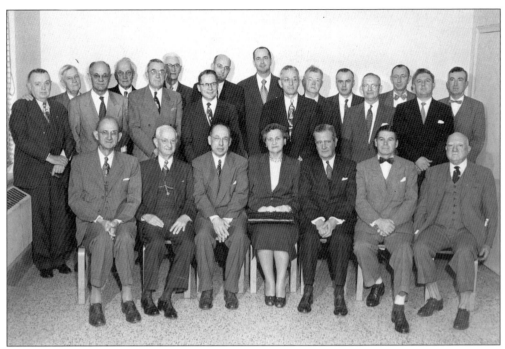

TRUSTEES OF WAKE FOREST. Dr. Tribble is pictured here along with the trustees of the college, who began planning and constructing the new campus in Winston-Salem.

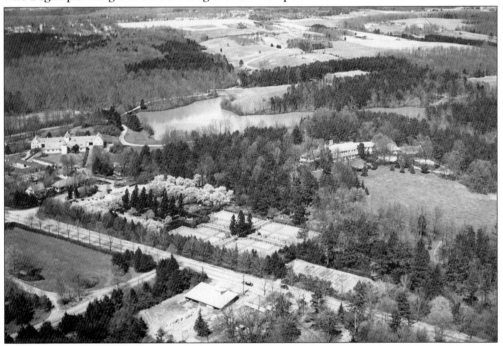

AERIAL VIEW OF NEW CAMPUS SITE. This 300-acre tract of land on the Reynolds estate in Winston-Salem was donated to the college by the daughter of R.J. Reynolds, Mary, and her husband, Charles H. Babcock, as the site of the new campus. The Babcock family made additional gifts to the college of adjacent tracks of land.

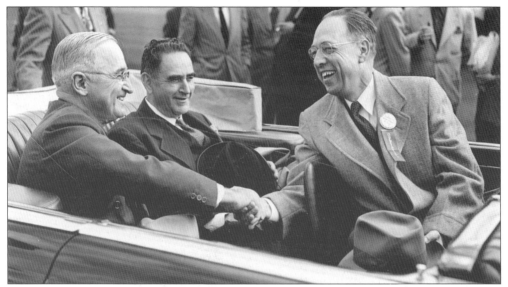

PRESIDENT HARRY TRUMAN, GOV. KERR SCOTT, AND DR. TRIBBLE. The groundbreaking ceremony for the new campus was held on October 15, 1951. President Truman was, at the time, making the sixth official visit to North Carolina by a sitting American president. The groundbreaking ceremony was covered extensively in national publications, including *Life* magazine.

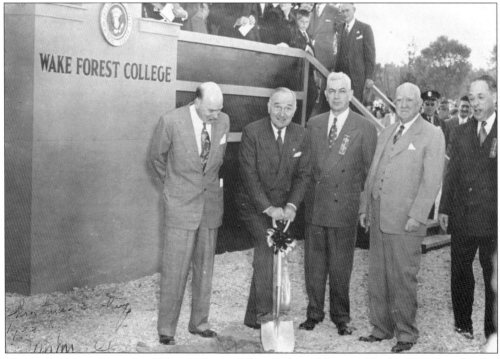

GROUNDBREAKING CEREMONY. Those pictured, from left to right, are Charles H. Babcock, who presented the college with the deed to the property; United States President Harry S Truman; Judge Hubert Olive, chairman of the Wake Forest College Board of Trustees; Odus Mull, a college trustee who helped plan the campus; and President Tribble.

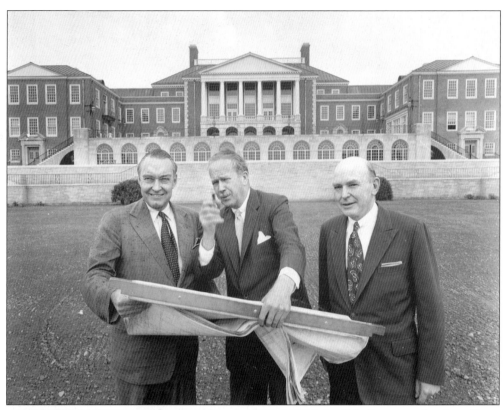

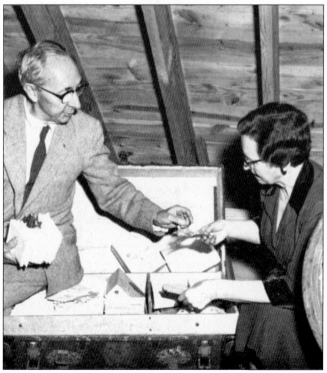

R.J. Reynolds Jr., Jens F. Larson, and Charles H. Babcock Review Plans on the New Campus. In 1946, the Board of Trustees established what would be called the Planning and Building Committee. Odus M. Mull was chairman of this board committee that put many years and countless long hours into planning and constructing the new campus. Jens F. Larson of New York was the chief architect responsible for designing the campus.

Sorting and Packing. Dr. and Mrs. H. Broadus Jones begin the process of sorting and packing their belongings for the trip to Winston-Salem.

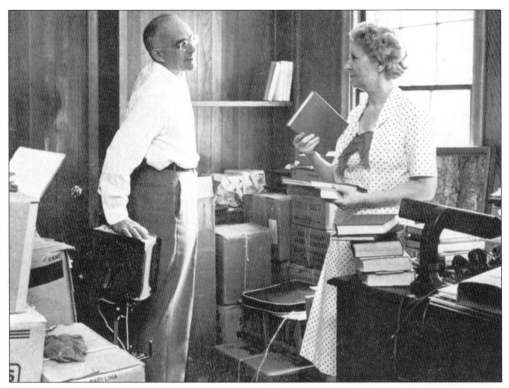

Dr. and Mrs. Allen Easley Prepare to Move. The task of relocating from Wake Forest was difficult for many families. Although excited about the prospects for the future, many faculty and staff were leaving behind friends and family. "St. Allen" joined the faculty to teach religion after serving for 10 years as the college chaplain and pastor of the Wake Forest Baptist Church. He served the college from 1938 until his retirement in 1963. He was sometimes referred to as the conscience of the institution. He chaired the committee that led to the integration of the college and introduced the faculty resolution asking the merchants of Winston-Salem to desegregate.

Moving the Library. Mr. Carlton West supervised the monumental task of packing and then unpacking the library.

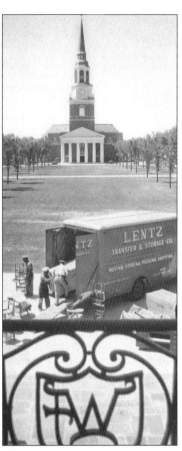

THE CAMPUS ARRIVES. Some of the contents of the old campus are unloaded across the plaza from Wait Chapel. The architects of the new campus took great pains to make the new campus architecture resemble the old campus as much as possible.

THE STUDENTS ARRIVE. Students arrive in time for the fall 1956 term. During the construction of the new campus, students were bused to Winston-Salem to view the progress in the construction of the facilities.

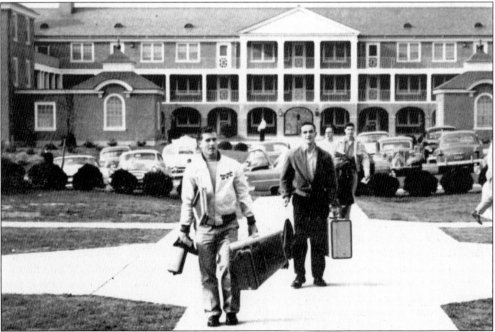

WAIT CHAPEL UNDER CONSTRUCTION. The foundations for Wait Chapel (named for the college's first president), the library, and Reynolda Hall were the first to be laid following the groundbreaking ceremony.

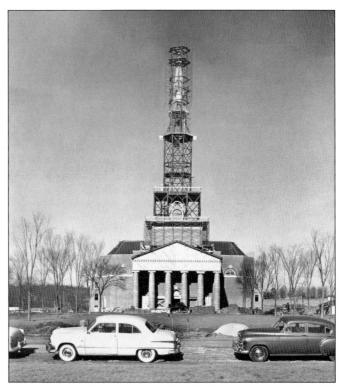

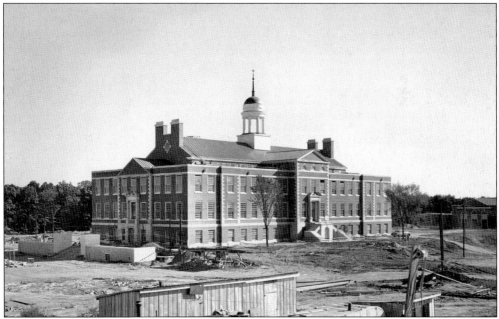

Z. SMITH REYNOLDS LIBRARY. A budget of $1,691,567 was established to build the new library. It was named after the son of R.J. Reynolds. The budget to construct buildings sufficient in size to relocate the college originally was estimated to be $17.5 million. A total of 22 buildings were ultimately envisioned, with estimated costs totaling $25 to $30 million. Inflation, construction delays, and other factors made those projections unrealistic.

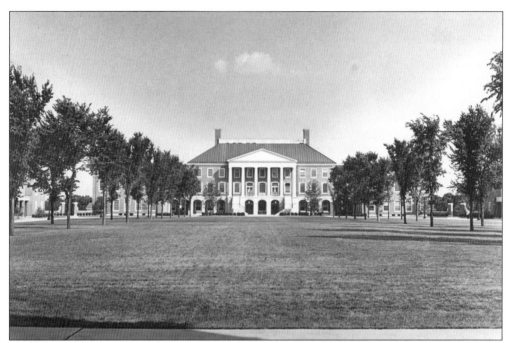

REYNOLDA HALL. All of the new campus buildings were constructed in a Georgian style of Virginia brick with limestone trim. Although the original plan was to relocate the campus in 1955, construction delays pushed the move back to the summer of 1956. Reynolda Hall was completed in 1954.

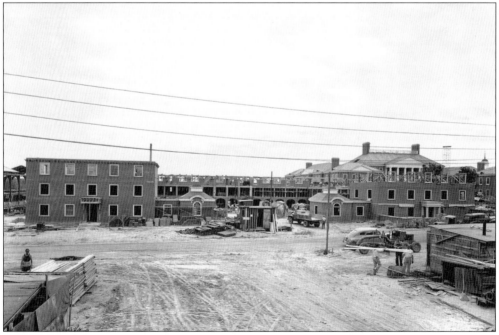

KITCHIN DORMITORY. The new campus was to include four men's dormitories and two for women. Kitchin Dormitory was built to house men and was named for former Wake Forest President Thurman D. Kitchin. It was constructed between 1953 and 1955.

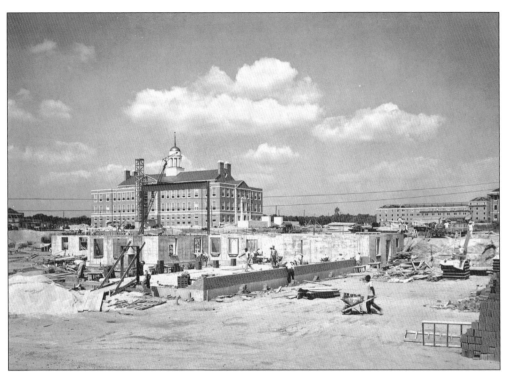

JOHNSON DORMITORY. Housing for women, Johnson Dormitory was constructed between 1954 and 1956. This dormitory was named for Lois Johnson, the first dean of women on the old campus.

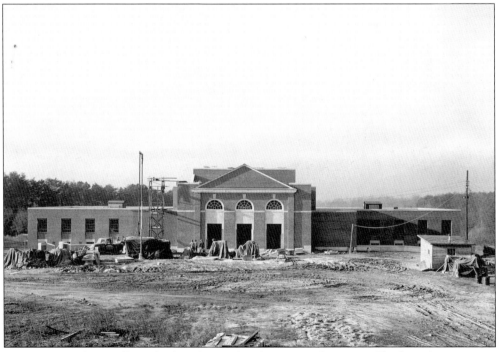

SALEM HALL. Salem Hall was built to house the chemistry, physics, and biology departments.

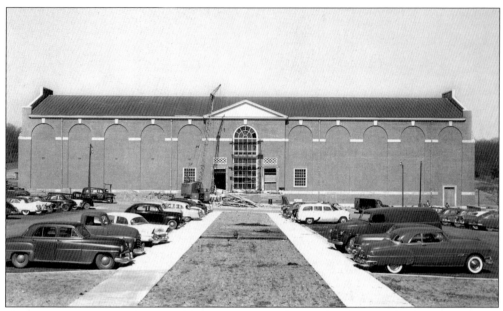

REYNOLDS GYMNASIUM. The Reynolds Gymnasium was completed in 1956. The original plan was for 14 buildings to be completed in time for the move to Winston-Salem. Other buildings would remain under construction, but enough classroom space and dormitory space would exist to relocate the college.

FACULTY APARTMENTS. To assist the faculty and staff in relocating to Winston-Salem, the college established a $300,000 fund to purchase their Wake Forest homes. Land contiguous to the new campus had been set aside for homes, and this program was very successful in allowing employees to proceed with building new homes. When the college resold the properties in Wake Forest, it was determined that this transaction cost the college only $5,000. Apartments provided temporary housing for faculty while their new homes were under construction and permanent housing for those who wished to remain there. These apartments were completed in 1956.

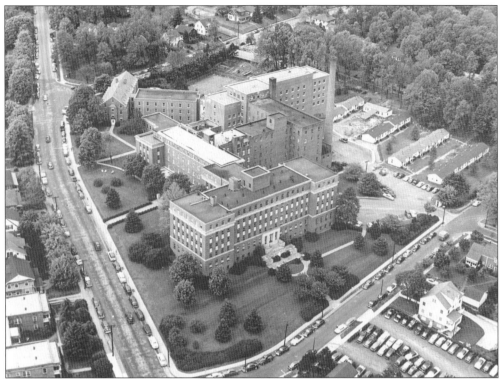

BOWMAN GRAY SCHOOL OF MEDICINE AND BAPTIST HOSPITAL. The relocation of the undergraduate programs in 1956 reunited the college with the Bowman Gray School of Medicine, which had relocated to Winston-Salem in 1941 to become associated with Baptist Hospital.

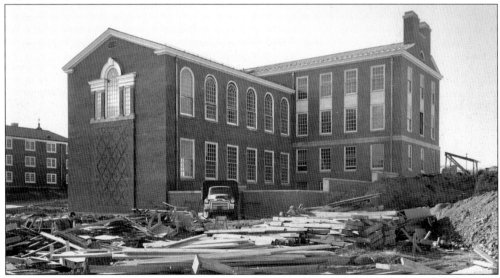

LAW SCHOOL. On the old campus, the law school shared space with the library and the department of social science. Dean Carroll W. Weathers is said to have stated that "unless the law school had its own building on the campus in Winston-Salem, the law school was content to stay in Wake Forest." This building was completed in 1956.

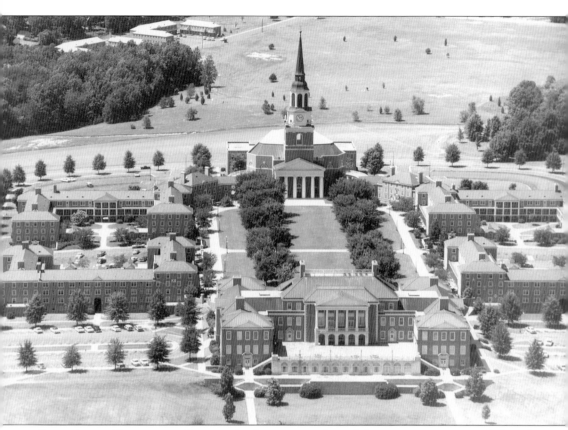

EARLY AERIAL VIEW OF THE CAMPUS. As the construction of the campus progressed, board member William J. Conrad remarked that the college was "extremely fortunate in being able to plan and construct an entire campus over a short period of time. Wake Forest's new home will be one of the most beautiful in the nation and at the same time one of the most functional and economical to operate." The campus landscaping plan included the planting of 46 elms, 82 willow oaks, 36 pin oaks, 20 dogwoods, 15 maples, 4 chestnut oaks, a water oak, 4 magnolias, 2 beeches, 2 osmanthus, a horse chestnut, and a wisteria.

Five
ATHLETICS THROUGH THE YEARS

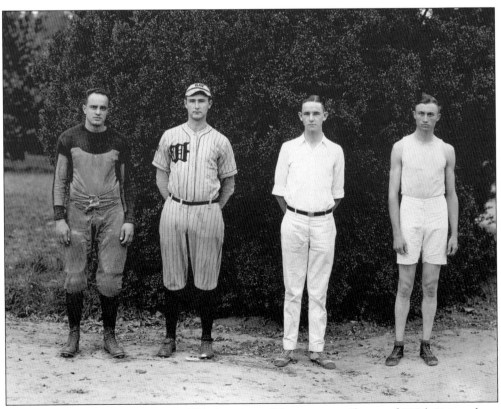

EARLY ATHLETIC SPORTS UNIFORMS. This is a view of the sports uniforms of 1924. Pictured are members of the football, baseball, tennis, and track teams.

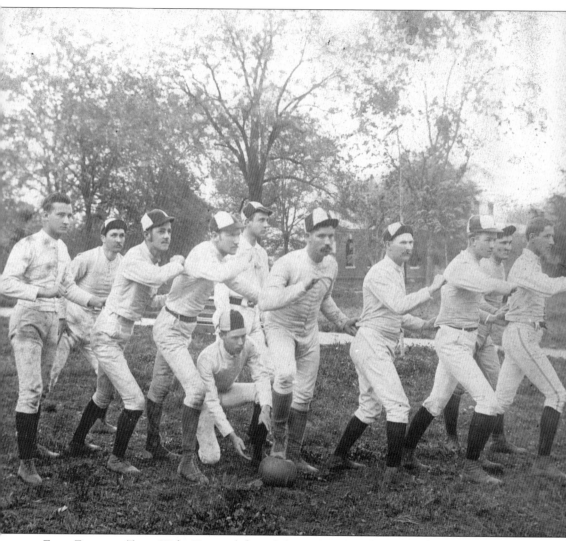

First Football Team. Wake Forest defeated the University of North Carolina 3-2 in the first college football game played in North Carolina. The game, which was held at the State Fair Grounds in Raleigh, took place on October 18, 1888. Football at Wake Forest proved to be controversial in the early years, and the trustees voted to abolish the sport in 1895. Herbert Peele, the editor of *The Student*, appealed to the trustees in 1907 by saying, "Why should Wake Forest students be longer the sissies among college men, tied to the apron strings of a too fond Alma Mater and held back from a sport that is manly and clean." Popular demand led to the re-establishment of football in 1908.

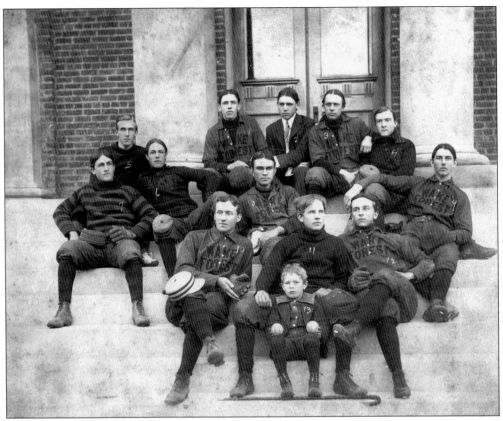

BASEBALL TEAM FROM 1901. In May 1891, Wake Forest played in the first college baseball game in North Carolina. Wake Forest defeated North Carolina 10-7 in the contest, which was played in Raleigh. It was a common custom in the early 1890s for college teams to hire professional players to round out their rosters.

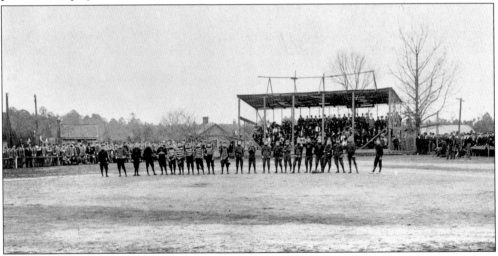

EARLY BASEBALL TEAM AND FIELD. Baseball was a very popular sport at the turn of the century. This view shows the baseball field on the "playing grounds" where the Calvin Jones House now stands.

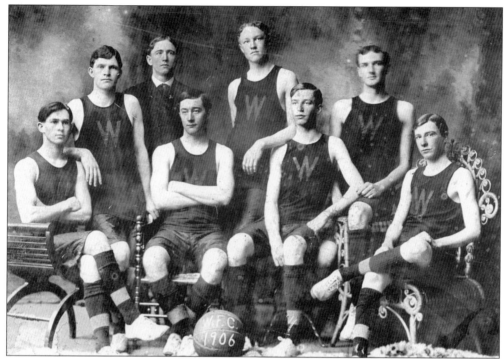

The 1906 Basketball Team. Wake Forest fielded its first basketball team in 1906. This team defeated Trinity College (now Duke University) in its first contest 24-10. Wake Forest's first Director of Athletics, J. Richard Crozier, is credited with introducing basketball to the state in 1905.

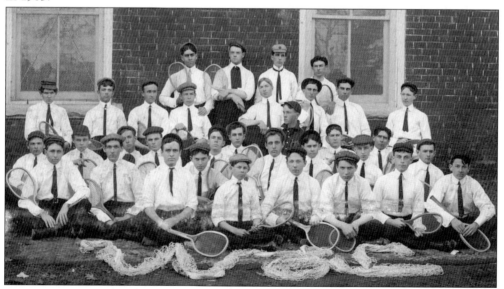

The Tennis Club in 1904. Tennis was an early favorite sport on campus. In the spring of 1907, the squad captured the singles and doubles championships in the Southern Intercollegiate Tennis Tournament held in Atlanta. The team of E.B. Earnshaw and Hubert M. Poteat, who were both to have lifelong associations with the college, won the doubles competition and lost only one match in four years of intercollegiate competition.

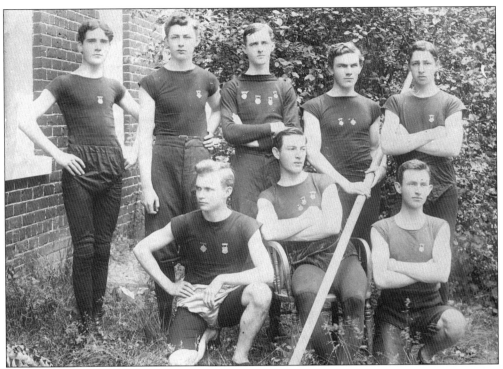

EARLY TRACK TEAM. The Olympic sports, including track and field, were very popular with students, but in the early years they did not receive much support from the college. Teams often had to purchase their own uniforms.

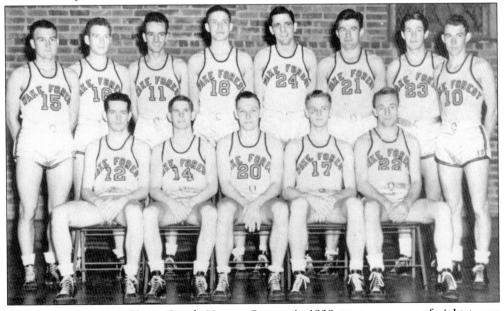

THE 1939 BASKETBALL TEAM. Coach Murray Greason's 1939 team was one of eight teams selected to participate in the first NCAA basketball tournament. The Deacons lost to Ohio State 64-52 in the first round. They led late in the game until their leading scorer, Jim Waller, fouled out.

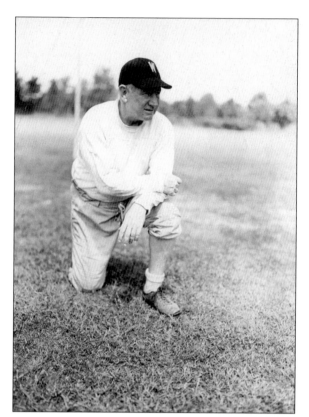

"Peahead" Walker. Peahead was a successful and popular Deacon football coach from 1937 to 1950. He led the team to a record of 77 wins and 51 losses in 14 years as the head coach.

Band in the Peahead Formation. The band performs in the "Peahead" formation at a football game in Groves Stadium on the old campus.

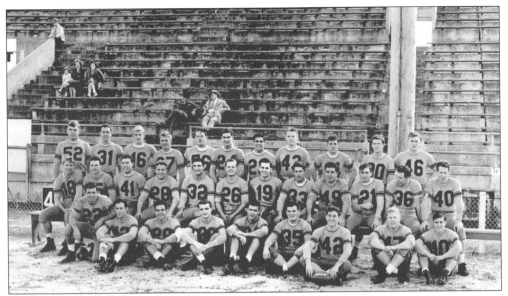

THE 1946 FOOTBALL TEAM. The Deacon football teams of the mid-to-late 1940s enjoyed several successful seasons. The 1945 Deacons were the first to participate in a postseason bowl game. Wake Forest defeated South Carolina in the inaugural Gator Bowl, 26-14. The team finished with a record of 5-3-1. The 1946 team defeated the fourth-ranked Tennessee Volunteers 19-6 in Knoxville in one of the season's biggest upsets. The 1948 team also participated in a bowl game, losing to Baylor 20-7 in the 1949 Dixie Bowl in Birmingham, Alabama. That team finished with a record of 6-4.

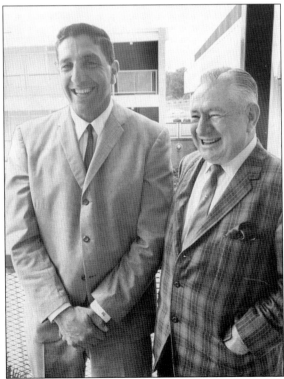

FOOTBALL PLAYER BILL GEORGE WITH COACH PEAHEAD WALKER. Bill George was an All-American defensive tackle for Wake Forest in 1949. He went on to become an eight-time All-Pro for the Chicago Bears. He is now a member of the Pro Football Hall of Fame. George also represented Wake Forest in wrestling in the Southern Conference, even though Wake Forest had no official wrestling team. In 1948, 1949, and 1952 George won the heavyweight wrestling championship.

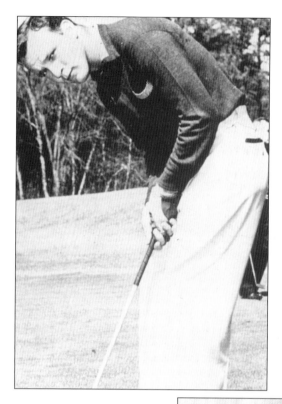

ARNOLD PALMER. Arnold Palmer won back-to-back NCAA individual national championships for Wake Forest in 1949 and 1950 prior to beginning his successful pro career. Palmer was the first Deacon to win a national individual athletic title. In four years of collegiate golf competition, he was defeated only three times and his college scoring average for 18 holes was 69 strokes.

WAKE FOREST BASEBALL COACH JOHN CADDELL. John Caddell coached the baseball team from 1929 to 1940. His teams were always among the best in the state, and he was a popular figure with both students and alumni. Beginning in the 1890s, Wake Forest and NC State played the annual Easter baseball classic in Raleigh on Easter Monday. It is believed that the North Carolina State Legislature made Easter Monday a designated holiday for North Carolina to ensure that people would be able to watch the game.

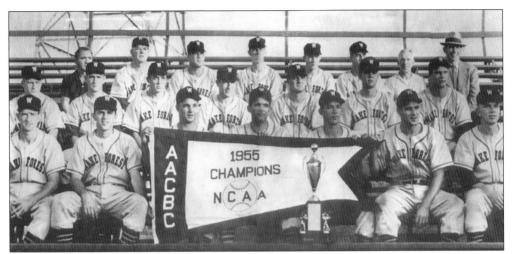

THE 1955 NATIONAL CHAMPIONSHIP BASEBALL TEAM. The baseball team of 1955 captured the National Championship for Wake Forest, defeating Western Michigan 7-6 in the title game. The team was subject to some criticism in Baptist circles for playing on Sunday. The Deacons captured the ACC title with a record of 11-3 prior to advancing in the NCAA tournament. Coach Taylor Sanford was voted national coach of the year, and catcher Linwood Holt was named All-American. The 1949 team had advanced to the national championship game, and the 1951 team took second place as the representative for the United States in the first Pan Am games in Argentina.

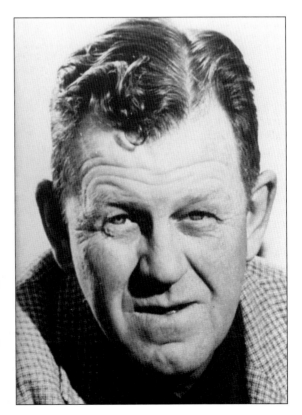

JIM WEAVER. Deacon athletic director Jim Weaver came to Wake as the football coach in 1933 and became athletics director three years later. He served in that capacity until he was selected as the inaugural commissioner of the Atlantic Coast Conference in 1953. Wake Forest was a member of the Southern Conference from 1936 to 1953. In 1953, the school left the Southern Conference to help form the ACC.

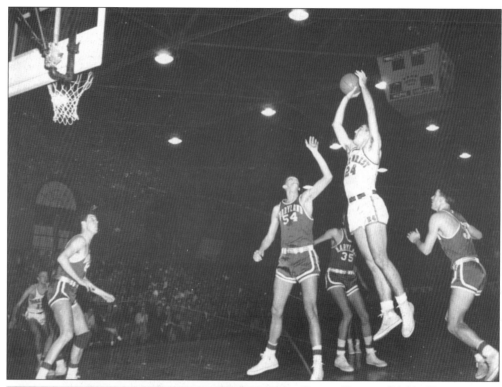

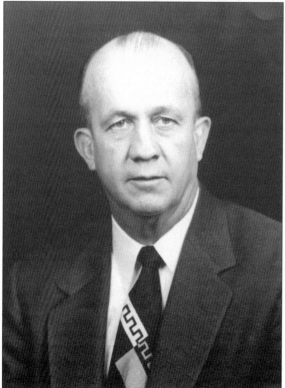

DICKIE HEMRIC. Dickie Hemric goes up for a shot against Maryland in Gore Gymnasium in 1955. Hemric was the ACC player of the year in 1954 and 1955, as well as the MVP of the 1955 ACC tournament. Hemric remains Wake Forest's career leader in scoring and rebounding. During his senior season, he averaged 27.6 points and 19 rebounds per game.

BASKETBALL COACH MURRAY GREASON. Coach Greason celebrated his 20th year in coaching at Wake in 1952 by cutting down the nets after defeating NC State 71-70 in the Southern Conference tournament finals. NC State had won the tournament 6 years in a row. As the basketball coach for 24 years, Greason had a record of 285 wins and 239 losses. An extremely popular coach, he was admired and respected throughout the South.

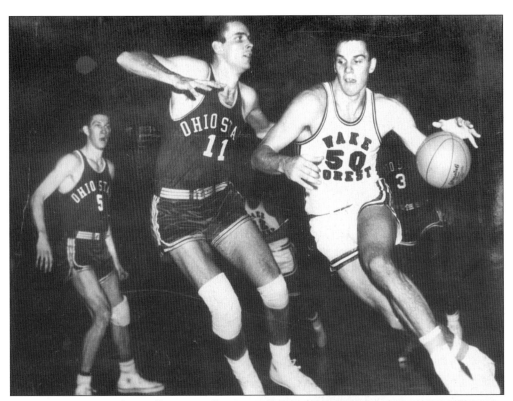

LEN CHAPPELL. Len Chappell was an All-American for Wake Forest in 1961 and 1962. He is shown here in the 1962 Final Four game against Ohio State. Chappell averaged over 30 points per game in his senior season prior to starting a 10-year career in the NBA.

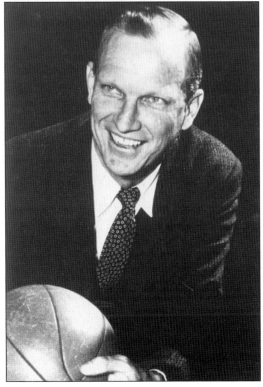

BASKETBALL COACH "BONES" MCKINNEY. Coach McKinney succeeded Murray Greason as basketball coach after the 1957 season. He took Wake Forest to the finals of the ACC tournament five years in a row between 1960 and 1964. He retired in the fall of 1965 with a record of 122 wins and 94 losses. A flamboyant personality, he was often rewarded for his sideline antics with technical fouls from the officials. To combat this problem, he designed and used a seat belt to restrain himself during games.

THE 1961 ACC BASKETBALL CHAMPIONS. In 1961, Wake Forest won its first ACC tournament. The Deacons won two rounds in the NCAA tournament before losing to St. Joseph's in the Eastern Regional finals.

THE 1962 FINAL FOUR BASKETBALL TEAM. The basketball team of 1962 again won the ACC tournament. In the NCAA tournament, the Deacons defeated Yale, St. Joseph's, and Villanova to advance to the Final Four. Wake Forest lost to Ohio State in the semifinal game 84-68 but beat UCLA in the consolation game to finish third in the nation.

BILLY PACKER. Billy Packer was a guard on the 1962 Final Four team and was named to the All-Atlantic Coast Conference team from 1960 through 1962. He served as an assistant coach at Wake Forest from 1965 to 1969. He has enjoyed a long career as a college basketball broadcaster.

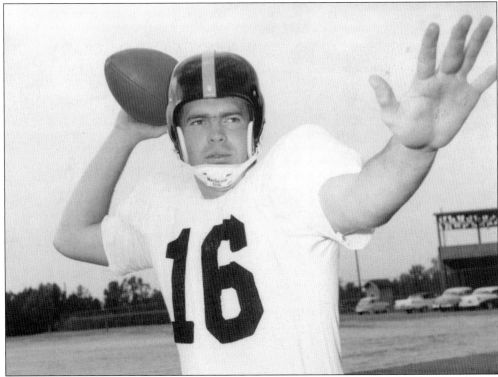

FOOTBALL PLAYER NORM SNEAD. Snead led the nation in passing in 1960 with 1,176 yards and went on to a career in the professional ranks.

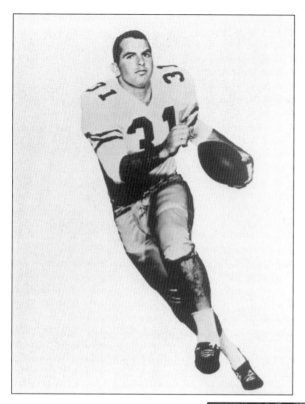

FOOTBALL LEGEND BRIAN PICCOLO.
Brian Piccolo was a popular student on campus and later the subject of the popular movie *Brian's Song*. During his senior year in 1963, he led the nation in scoring and was named the ACC Player of the Year.

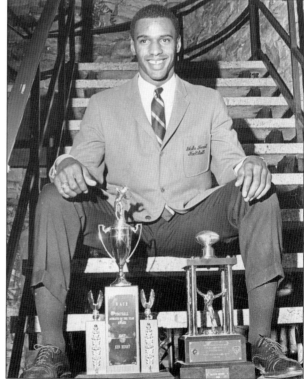

BUTCH HENRY. In 1964, Butch Henry became the first African-American student to attend Wake Forest on an athletic scholarship. Henry was a standout football player for the Deacons and ushered in the era of integrated sports teams at Wake Forest.

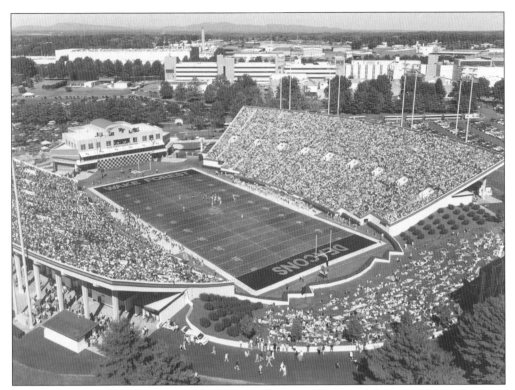

GROVES STADIUM. On September 14, 1968, the Deacons dedicated the new Groves Stadium in a game against NC State. This facility seats 31,500 and cost $4 million to construct. It has seen several improvements over the years, including the $8 million Bridger Field House in the north end zone, which houses locker rooms and athletic offices.

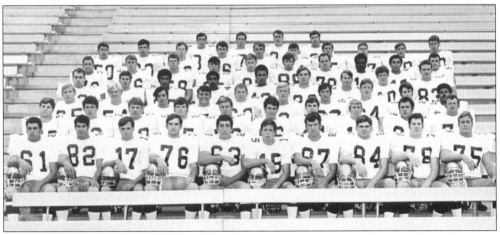

ACC CHAMPIONSHIP FOOTBALL TEAM OF 1970. The football team of 1970 captured its first and only ACC Championship with a record of 6 and 5. Predicted to finish last in the ACC, the Deacons started the season with three losses on the road. They won six of their last eight games to finish the season with a 5-1 league record to capture the conference title. Running back Larry Hopkins set a record for most rushing yards in a season with 1,228. Coach Cal Stoll was named ACC coach of the year.

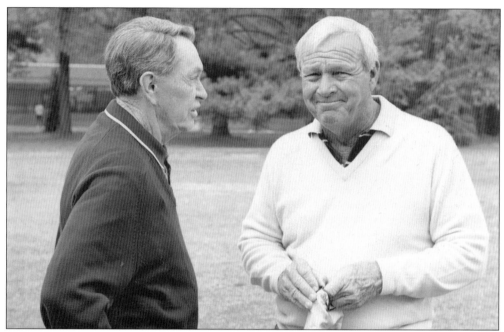

GOLF COACH JESSE HADDOCK WITH ARNOLD PALMER. Coach Haddock led many powerful golf squads at Wake from 1960 until his retirement in 1991. His teams captured three NCAA Championships, including back-to-back national titles in 1974 and 1975. The Deacons won 10 straight ACC championships from 1967 to 1977. Haddock's players earned All-American honors 63 times and more than 20 of his players went on to earn PGA tour cards. Many believe that Haddock was "the greatest college golf coach in history."

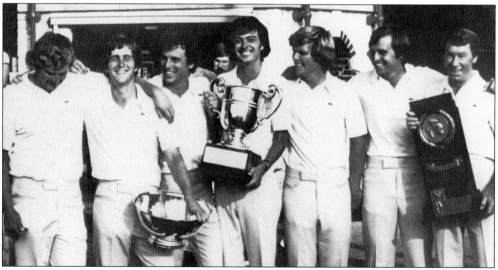

NATIONAL CHAMPIONSHIP GOLF TEAMS OF 1974 AND 1975. The men's golf team captured consecutive national titles for Wake Forest in 1974 and 1975. Pictured here are the beaming members of the 1975 title-winning team. In 1974, Curtis Strange became the youngest player ever to win the NCAA individual title. The following year, Deacon Jay Haas captured the individual title. In 1979, Gary Hallberg became the fourth Wake Forest golfer to win the individual title. The team had finished second in the nation in both 1969 and 1970.

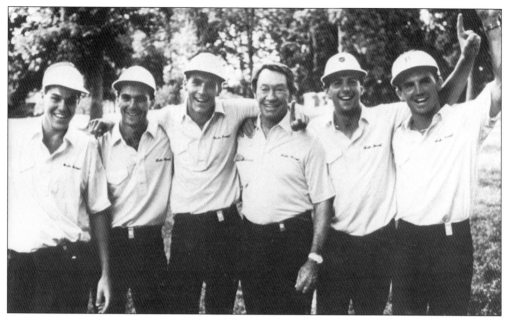

GOLF TEAM OF 1986. In 1986, the Deacons came from 16 strokes down on the final day of competition to win a third national title for the golf program.

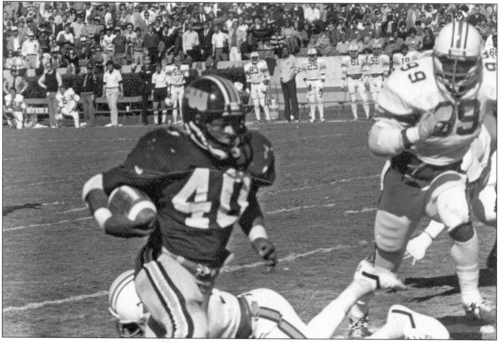

JAMES MCDOUGALD AND THE 1979 FOOTBALL TEAM. The 1979 football team, under the leadership of Coach John Mackovic, defeated 12th ranked Georgia in Athens and 13th ranked Auburn in Winston-Salem en route to the Tangerine Bowl. The Deacons lost to LSU 34-10 in that bowl to end the season with a record of 8-4. Running back James McDougald, pictured here, rushed for 1,177 yards in 1979 and 3,811 yards in his career. He is the career rushing leader at Wake Forest.

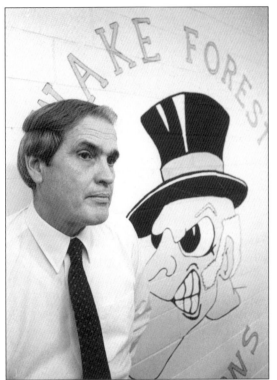

BASKETBALL COACH CARL TACY. Coach Tacy concluded his 13 year career at Wake Forest in 1985 with an overall record of 222 and 149. His Deacon teams went to four NCAA and two NIT postseason tournaments. The 1984 team advanced to the regional finals of the NCAA tournament before losing to Houston. Earlier in the tournament, Wake Forest ended the coaching career of DePaul coach Ray Meyer by defeating DePaul 73-71 in overtime. The Deacons also captured the Big Four tournament from 1975 to 1977 under the direction of Coach Tacy.

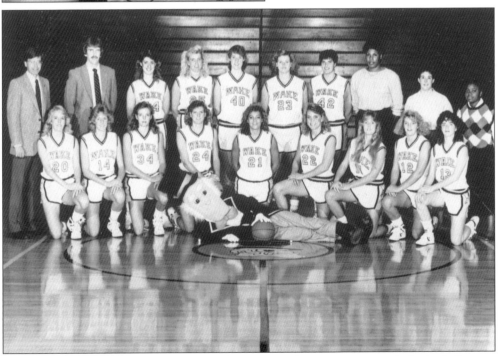

THE 1988 WOMEN'S BASKETBALL TEAM. The 1988 Wake Forest women's basketball team finished with a record of 23-8 and earned a trip to the NCAA tournament for the first time since being established as a varsity sport in 1971.

TENNIS COACH JIM LEIGHTON. Leighton was a long-time coach of the men's tennis program, serving from 1963 to 1984. He compiled a record of 277 wins and 172 losses and was named the ACC coach of the year in 1981. The tennis stadium is named in his honor.

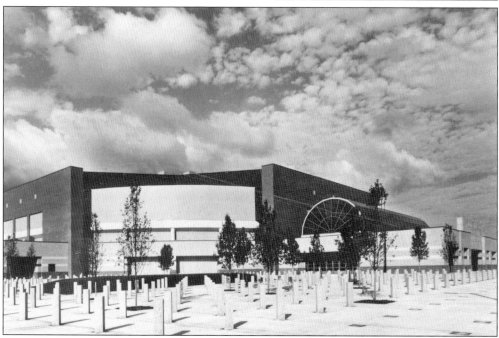

LAWRENCE JOEL VETERANS MEMORIAL COLISEUM. The Joel Coliseum was opened in 1989. For many years prior to the opening of the Joel Coliseum, most of the ACC games were played in Greensboro for lack of an adequate facility in Winston-Salem. The Joel Coliseum is the home of both the men's and women's basketball programs.

GENE HOOKS. Gene Hooks served as the Director of Athletics at Wake Forest from 1964 to 1992. As a student, he was also a two-time All American baseball player for the Deacons in 1949 and 1950. Hooks also served his alma mater as the baseball coach.

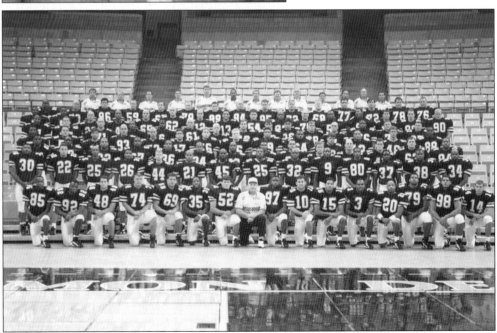

THE 1992 FOOTBALL TEAM. The 1992 football team completed a successful season by defeating Oregon 39-35 in the Independence Bowl to finish 8-4. Coach Bill Dooley retired following this season.

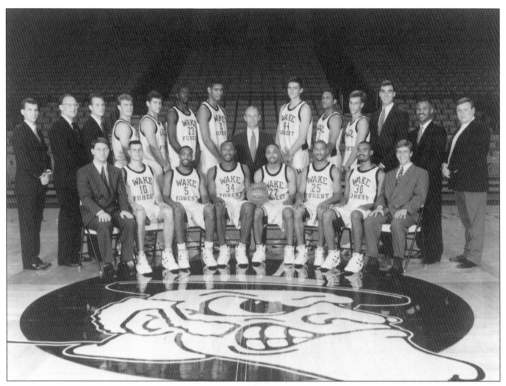

THE 1995 ACC CHAMPION BASKETBALL TEAM. In 1995, the men's basketball team won the ACC tournament for the first time since 1962 and advanced to the final eight of the NCAA basketball tournament. Senior Randolph Childress and sophomore Tim Duncan led the team. The 1996 team also won the ACC tournament.

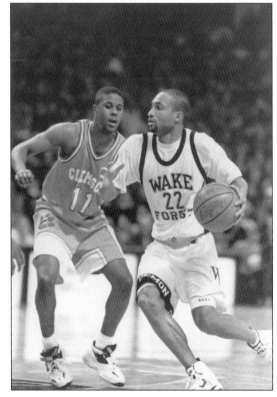

RANDOLPH CHILDRESS. Senior Randolph Childress set a new scoring record in the 1995 ACC tournament by scoring 107 points in leading his team to the championship. Childress scored with 4 seconds remaining in overtime to help Wake Forest defeat North Carolina 82-80 in the championship game. Childress was one of the leaders in the resurgence of the Wake Forest basketball program in the 1990s under the leadership of Coach Dave Odom.

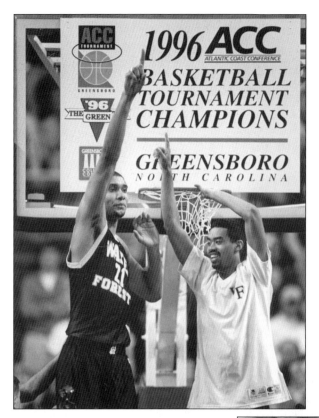

TIM DUNCAN. Pictured here with teammate Tony Rutland following the ACC tournament victory in 1996, Tim Duncan (number 21) was the National Player of the Year in 1996 and 1997. He led Wake Forest to four straight 20-win seasons and became the 10th player in NCAA history to score 2,000 points and grab 1,500 rebounds. Duncan was the first overall pick in the 1997 NBA draft and has led the San Antonio Spurs to two NBA titles. Duncan was named the 1998 rookie of the year in the NBA and has been named Most Valuable Player in the league on two occasions.

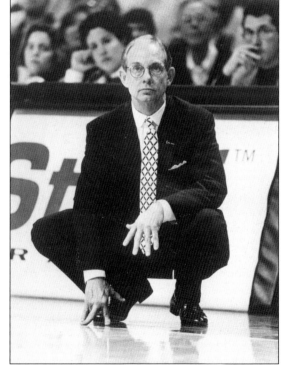

DAVE ODOM. Dave Odom was the men's basketball coach of the Demon Deacons from 1990 to 2001, guiding the team to a record of 240 wins and 132 losses. During his tenure, Wake Forest collected two ACC titles and advanced to postseason play 11 times. The Deacons captured the NIT title in 2000 and advanced to the NCAA final eight in 1996.

ANDY BLOOM. In 1996, Andy Bloom captured the NCAA Championship in both the shot put and the discus. Wake Forest participated in its first off-campus track and field event in 1909. These sports were extremely popular in the early days of intercollegiate competition.

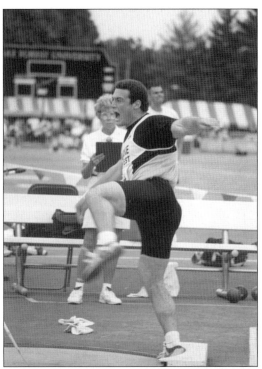

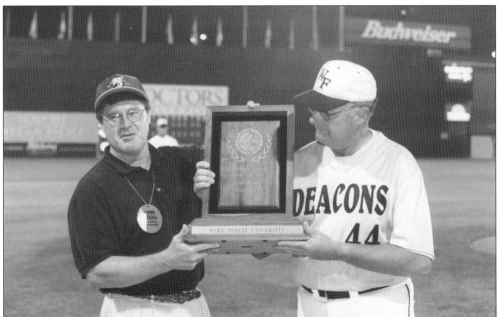

ACC COMMISSIONER JOHN SWOFFORD AND BASEBALL COACH GEORGE GREER. Coach George Greer accepts the ACC tournament trophy following the Deacons' win over Clemson in the 1999 championship game. As the Wake Forest coach for 16 years, Greer has led the Deacons to three ACC Championships, produced 28 All-Americans, and compiled the fourth-best record in the history of the ACC. Since 1988 Greer's teams have won 591 games while losing only 349.

THE 1998 BASEBALL TEAM. The 1998 baseball team captured the ACC title for the first time in 21 years and earned the team's first bid to the NCAA tournament since 1977. The 1999 team also won the conference tournament while the 2001 team earned the third ACC title for the Deacons. In 2002, Wake Forest was ranked as high as second nationally and earned a fifth straight trip to the NCAA tournament.

GENE OVERBY, "THE VOICE OF THE DEACONS." Gene Overby was the longtime radio voice of Wake Forest basketball and football. He served in this capacity for 17 years beginning in 1972. At the time of Overby's death in 1989, President Hearn said, "He was Wake Forest's number one fan, and his enthusiasm and positive outlook inspired all who knew him. He believed in and represented what Wake Forest stands for on and off the playing field."

BEA BIELIK. In 2002, Wake Forest tennis player Bea Bielik won the national championship in singles. She established a new record for the fewest games lost in dominating the tournament. She prevailed in the championship match 6-2, 6-0. Bielik led the Lady Deacons to 24 wins during the regular season and a quarterfinal finish in the team NCAA championship.

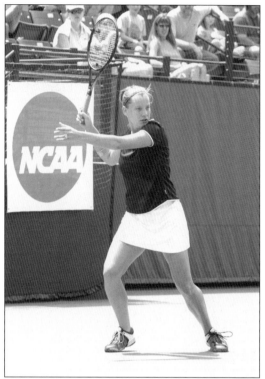

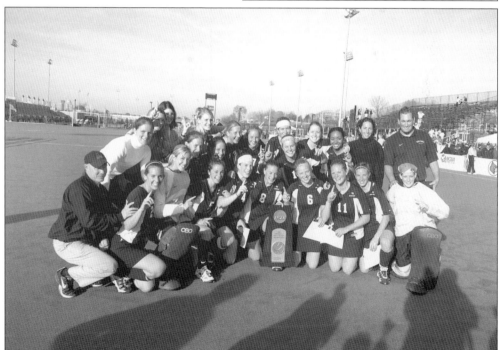

NATIONAL CHAMPIONSHIP IN FIELD HOCKEY. The first women's team to capture a national championship for Wake Forest was the 2002 field hockey team. The team defeated Penn State 2-0 in the national championship game.

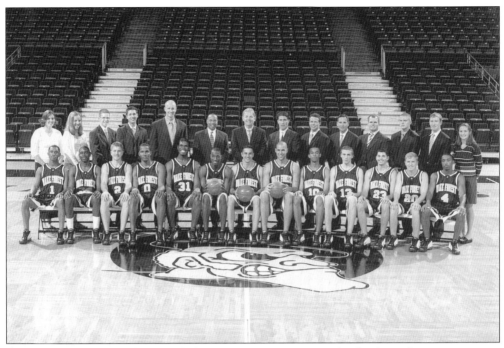

THE 2003 BASKETBALL TEAM. By defeating NC State 78-72 in the final regular season game, Wake Forest's men's basketball team captured its first outright ACC regular season title in 41 years. The team finished with a record of 25 wins and 6 losses. Senior Josh Howard was named the consensus ACC Player of the Year. The team advanced to the second round of the NCAA tournament.

ATHLETICS DIRECTOR RON WELLMAN. Since becoming the Director of Athletics in 1992, Ron Wellman has overseen an extensive facility improvement program. Under Wellman's leadership, many of the Demon Deacon athletic teams have been ranked in the top 25 in their respective sports. Wake Forest has also maintained an extremely high graduation rate, indicative of the high caliber of student-athlete recruited by the coaching staff.

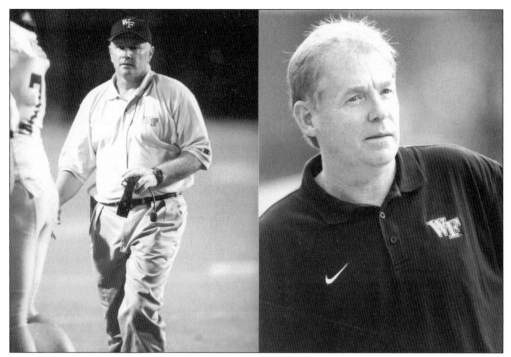

FOOTBALL COACH JIM GROBE AND BASKETBALL COACH SKIP PROSSER. Since becoming the head football coach in 2002, Jim Grobe has steered Wake Forest to consecutive winning seasons, including a Seattle Bowl victory over Oregon. The men's basketball team has enjoyed similar success in recent years under the leadership of Skip Prosser. Coach Prosser guided the Deacons to successive NCAA tournament berths in his first two years as head coach. The 2003 team captured the ACC regular season title and advanced to the second round of the NCAA tournament.

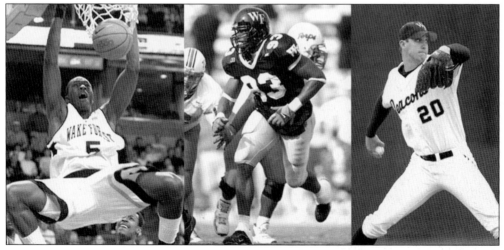

JOSH HOWARD, CALVIN PACE, AND KYLE SLEETH. In 2003, Wake Forest had athletes drafted in the first round in professional basketball, football, and baseball. Stellar baseball pitcher Kyle Sleeth was selected third overall by the Detroit Tigers, while defensive end Calvin Pace was selected as the 18th pick by the Arizona Cardinals. Josh Howard was named the ACC Basketball Player of the Year and was selected 29th overall by the Dallas Mavericks.

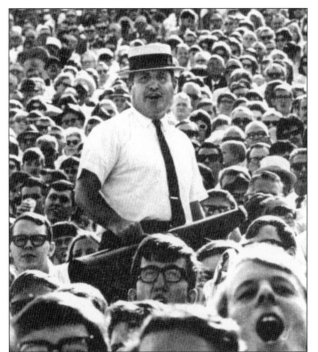

"Doc" Murphrey. Doc entered Wake as an undergraduate in 1946 and graduated from the law school in 1957. He was a fixture at Wake Forest athletic events for years and symbolized friendliness, school spirit, and devotion to Wake Forest. When the Deacons needed a lift from the crowd, Doc could be counted on to rally the Wake Forest faithful.

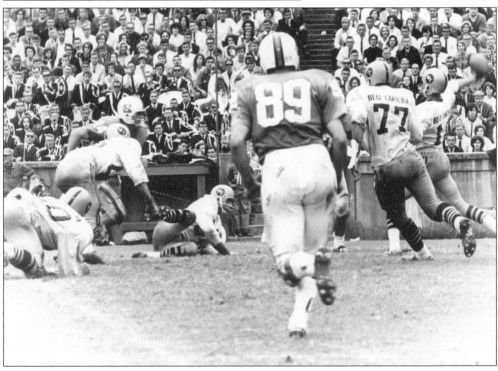

Competition among the Big 4. The proximity of Wake Forest, Duke, NC State, and the University of North Carolina led to the development of intense rivalries among these schools in the early days of intercollegiate competition. Note the back of the Wake Forest jerseys in this 1950s era photograph.

JEFF DOBBS. Jeff Dobbs was the Demon Deacon in 1974-1975 and developed a huge following for his ability to get the crowd into the action.

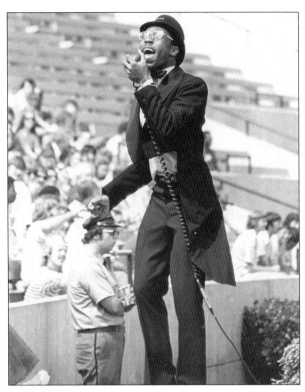

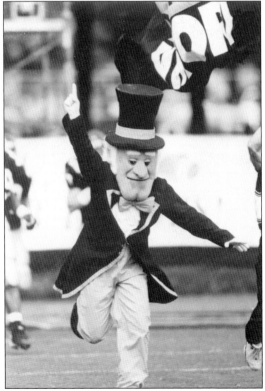

THE DEMON DEACON MASCOT. The nickname, Demon Deacons, dates to 1922 and was coined by sports editor Mayon Parker of Ahoskie. Wake Forest student Jack Baldwin was the first "Demon Deacon" in 1941. At the time, Wake Forest was the only team in the state without a mascot. During a game with the University of North Carolina in 1942, Baldwin rode onto the field on the back of the Carolina ram. Network sportscaster Bob Costas remarked in 1989, "[The Demon Deacon is] the mascot of protocol. I've never seen him be rude. He represents the gentility of the Old South; a very dapper guy, sharply dressed and well tailored."

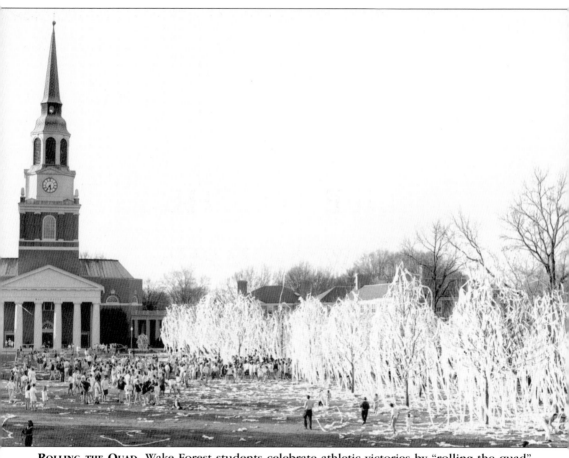

ROLLING THE QUAD. Wake Forest students celebrate athletic victories by "rolling the quad" with toilet paper. This picture was taken on March 12, 1995, following Wake Forest's victory in the championship game of the ACC basketball tournament.

Six

LIFE ON THE
NEW CAMPUS

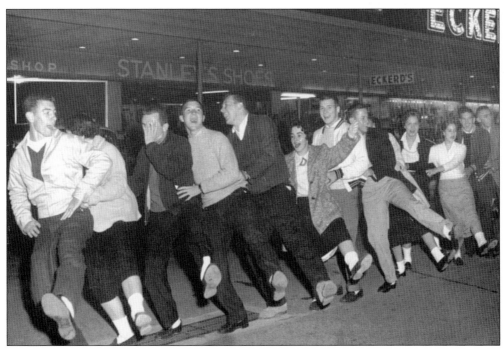

DANCING ON CAMPUS. Dancing on campus had been debated for some two decades before it was finally approved in 1957 by the Board of Trustees. Twenty years earlier, in 1937, the State Baptist Convention had specifically prohibited dancing by stating, "We disapprove and condemn the modern dance as a means of social amusement. We recognize that it is demoralizing and that it tends toward immorality." This 1958 picture shows students dancing in a line.

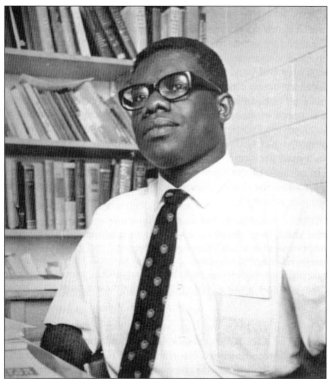

EDWARD REYNOLDS. The college trustees ended segregation at Wake Forest in 1962. Edward Reynolds, a transfer student from Shaw University, was the first black student to enroll as a regular undergraduate.

PROVOST EMERITUS ED WILSON. Edwin G. Wilson (Class of 1943) has served the university in many capacities. Starting in 1951 as an English professor, Dr. Wilson was assistant dean of the college from 1957 to 1958 and dean from 1958 to 1967. He was appointed provost in 1967 and held that position until 1990; he now serves as Provost Emeritus. Ed Wilson was a much beloved teacher and administrator and the Wilson Wing of the library was named in his honor in 1992.

MARK H. REECE. Remembered primarily as the dean of men, Mark Reece (Class of 1949) began his long tenure at Wake Forest in 1956 when he was hired as associate director of alumni relations. Within two years he was promoted to director of student affairs, overseeing all aspects of the student union. In 1963, Reece was promoted once again, this time to dean of men, a position he held until becoming dean of students in 1984. Along with notable political and social activists, Wake Forest hosted concerts by singer-songwriters like Simon and Garfunkel, Joan Baez, and Peter, Paul, and Mary. Most notable, however, is the role that Reece played in creating the student union's contemporary art collection, now named in his honor. His enduring contributions to the Wake Forest community were recognized in 1996 when he was awarded the Medallion of Merit.

CHAPLAIN ED CHRISTMAN. Ed Christman (Class of 1950, J.D. 1953) served his *alma mater* as chaplain from 1969 to 2003.

DR. RICHARD JANEWAY. Dick Janeway served as dean of the Bowman Gray School of Medicine from 1967 to 1994 and as executive vice president for health affairs from 1990 until 1997, after which he stepped down to become a professor with the university's joint MD/MBA program. At one time, he was the longest tenured dean of a medical school in the United States. Under his leadership, Janeway transformed the medical center into a healthcare facility consistently ranked among the nation's top 50 hospitals in cancer, cardiology, and geriatrics by the *U.S. News & World Report's* Annual Guide to America's Best Hospitals.

THE INAUGURATION OF PRESIDENT JAMES RALPH SCALES. Hubert H. Humphrey, Harold Tribble, James Ralph Scales, and Ed Wilson are pictured at the1968 inauguration of Dr. Scales. Dr. Scales served as president of Wake Forest University from 1967 to 1983. During his years at Wake Forest, the university grew in enrollment, physical plant and budget, and academic stature. New departments were established in art, business, and accounting. The Babcock Graduate School of Management began under his leadership. During his tenure, the university intensified its interest in international education, offering many courses abroad and establishing two houses for international study. Casa Artom on the Grand Canal in Venice was established in 1971 and the Worrell House in London was dedicated in 1977. Both of these study centers continue to house students pursuing accredited foreign study.

THE WORRELL HOUSE. Since 1977, hundreds of students have traveled to Wake Forest's Worrell House in London to spend a semester learning about theater, art, literature, and the history of London and Great Britain. The four-level Worrell House, built in 1875, stands at 36 Steele's Road in the Hampstead area of London near Regent's Park. The house was a gift from Eugene Worrell (Class of 1940) a Virginia newspaper publisher. Wake Forest also offers study abroad opportunities at Casa Artom (Venice) and Flow House (Vienna).

THE JAMES R. SCALES FINE ARTS CENTER. The James R. Scales Fine Arts Center was opened in 1976, and its contemporary design is appropriate to the functions of studio art, theatre, musical and dance performances, and instruction in art history, drama, and music. Extending from its lobby is the Charlotte and Philip Hanes Gallery for special exhibitions. In the art wing are spacious studios for drawing, painting, sculpture, and printmaking, along with a smaller gallery and classrooms. In the theater wing are design and production areas and two technically complete theaters, the larger of traditional proscenium design and the smaller for experimental ring productions. The music wing contains the Brendle Recital Hall for concerts and lectures, classrooms, practice rooms for individuals and groups, and the offices of the music department.

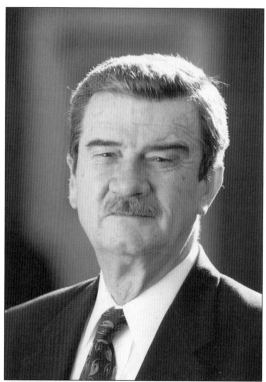

BILL STARLING. William G. Starling (Class of 1957) joined the admissions office in 1958 as assistant director and became the university's director of admissions in 1961. In 1968, he also became the director of financial aid. He was named dean of admissions and financial aid in spring 2001. Starling became ill on June 18, 2001, at an admissions program on campus and died suddenly later that day. Wake Forest named its Admissions Building and Welcome Center in memory of Starling at an October 26, 2001 ceremony on the building's front lawn.

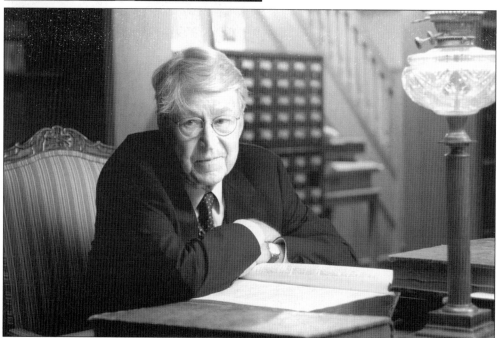

RUSSELL BRANTLEY. Russell Brantley (Class of 1945) served Wake Forest as Director of Communications from 1953 to 1987 and was a consultant for three university presidents. He attracted much attention for publishing a novel titled *The Education of Jonathan Beam* in 1962, a parody of the North Carolina Baptist State Convention.

PRESIDENT THOMAS K. HEARN JR. Dr. Hearn was inaugurated in the fall of 1983 and celebrated his 20th year in office in the fall of 2003, one of the longest tenures in major American universities. During his presidency, the university has been repositioned from a regional university to a national institution. Under his leadership, the university has undertaken a major technology initiative, and Wake Forest is now recognized as a leading laboratory for academic technology. The John Templeton Foundation recognized Dr. Hearn in 1999 as among the 50 college and university presidents who "demonstrate a personal commitment to character development and preparing students for lives of personal and civic responsibility." Dr. Hearn is currently chairman of Idealliance, a community effort to bring technology-based companies to Winston-Salem, and chairman of the Board of Governors for the Center for Creative Leadership in Greensboro.

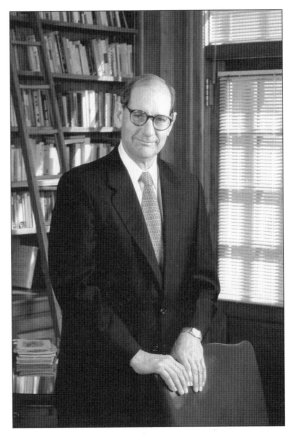

SESQUICENTENNIAL CELEBRATION OF 1983–1984. Beginning in 1983, the university celebrated its 150th birthday with a year of special events and academic programs.

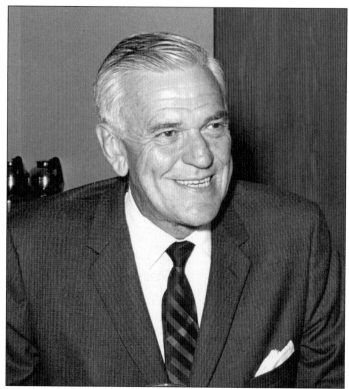

JOE BRANCH. Joe Branch, the former Chief Justice of the North Carolina Supreme Court, served as chairman of the Board of Trustees from 1970 to 1971 and from 1986 to 1987. Wake Forest has been led by many strong trustees during its long history. In 1986, the university entered into a new relationship with the State Baptist Convention of North Carolina. The Board of Trustees became self-perpetuating, and trustees were no longer appointed by the convention. This change allowed the university to operate independently for the first time since its founding in 1834.

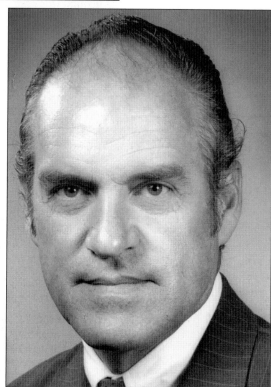

WESTON HATFIELD. Weston Hatfield served as chairman of the Board of Trustees from 1984 to 1985 and from 1988 to 1990.

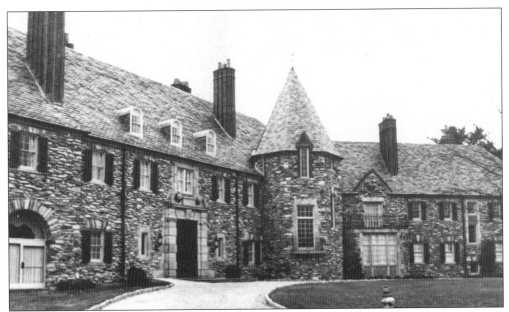

GRAYLYN CONFERENCE CENTER. Graylyn was first donated to the Bowman Gray School of Medicine in 1946. Following a subsequent gift to the university in 1972, Graylyn was used as a student dormitory. After damage by a fire in 1980, Graylyn was extensively renovated and opened as a conference center in 1984. The university took over its full-time management in 2001. Today, Graylyn has 98 guestrooms and 25 fully equipped meeting and breakout rooms; it attracts groups from around the country.

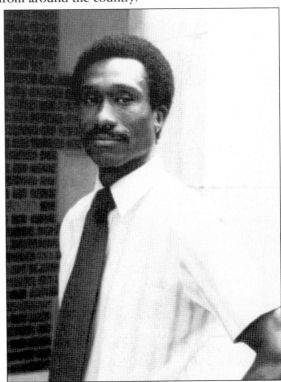

DR. HERMAN EURE. Dr. Herman E. Eure (Ph.D. 1974), who specializes in parasitology, ichthyology, and evolutionary biology, joined the biology department in 1974 and currently serves as department chair.

119

GIFT OF THE REYNOLDS HEADQUARTERS. When the R.J. Reynolds Corporation relocated its headquarters from Winston-Salem to Atlanta, the former headquarters complex was donated to Wake Forest. The 525,000-square-foot, five-story corporate office building adjacent to campus was transformed into the University Corporate Center (UCC), whose current tenants include Aon Consulting, BB&T, and Pepsi. This generous gift was, at the time, the largest unrestricted corporate gift in philanthropic history. The resulting rental income allowed the university to make significant investments in new buildings and academic programs. (Courtesy of Susan Mullally Clark.)

WORRELL PROFESSIONAL CENTER FOR LAW AND MANAGEMENT. Opened in 1993, the Worrell Center was designed by renowned architect Cesar Pelli and is named for alumnus, trustee, and benefactor Eugene Worrell (Class of 1940) and his wife, Anne, of Charlottesville, Virginia. This facility is home to the Babcock Graduate School of Management and the Wake Forest School of Law. Both programs are nationally recognized.

BENSON UNIVERSITY CENTER. Through generous gifts from trustees, alumni, parents, faculty, and friends of the university, the Benson University Center, a uniquely designed 100,000-square-foot facility, was opened in 1990. Dedicated and named for Clifton L. Benson Sr., the Benson University Center is an active community enrichment center on campus that is home to a variety of special university-wide events and student activities throughout the year. Visitors will find a state-of-the-art movie theater, Shorty's (a coffeehouse/tavern), food court, art gallery, multi-purpose meeting rooms, meditation room, and administrative and student organizational offices all located within the five different floors of the building.

PRESIDENT GERALD FORD. Former President Gerald Ford (right) is pictured with former Wake Forest president James Ralph Scales. Over the years, notables such as Martin Luther King Jr., Jimmy Carter, Margaret Thatcher, and Elie Wiesel have made speeches on campus.

OLIN PHYSICAL LABORATORY. Home to the physics department, Olin was opened in 1989 through the generosity of the Olin Foundation. The building contains lecture halls, teaching laboratories, a student computer room, study space, the student physics society room, a machine shop, a research computer, and research laboratories.

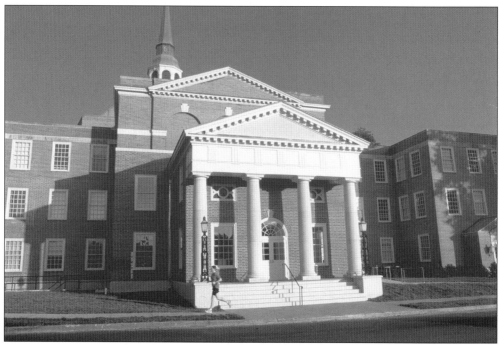

DIVINITY SCHOOL. In a reaffirmation of its Baptist heritage, Wake Forest University opened a divinity school in 1999 that is Christian by tradition and ecumenical in outlook. The nondenominational, three-year graduate program prepares students for careers in parish ministry.

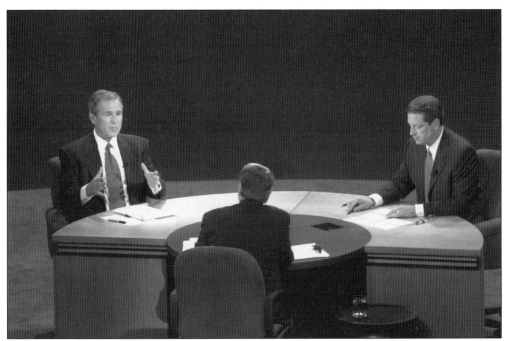

PRESIDENTIAL DEBATES. Wake Forest University's emergence on the national scene is exemplified by the fact that it is the only university to host two Presidential debates. In 1988, the university hosted a debate between Michael Dukakis and George H.W. Bush. The picture above was taken during the 2000 debate between Al Gore and George W. Bush.

CLOSING THE ROAD THROUGH CAMPUS. Since the establishment of the campus in the mid-1950s, the most direct route from Reynolds Road to University Parkway was through the Wake Forest campus. The Silas Creek Parkway extension, completed in 1991, redirected more than 12,000 cars per day that previously drove through the campus. (Courtesy of Susan Mullally Clark.)

Replacing the Elms on the Quad. The elms, which were planted on the quad in 1957, began to die from Dutch Elm disease by the late 1980s. Beginning in 1988, they were replaced with Autumn Ash, a more disease resistant species of tree.

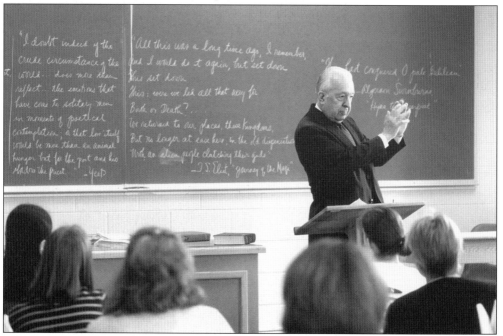

U.S. News & World Report **University Rankings.** In 1994, Wake Forest University was shifted from the regional to the national universities category by *U.S. News & World Report* and placed in the first tier (those ranked 26–57). It has consistently remained among the top 30 institutions in the nation.

AL HUNT. Washington political analyst and television personality Al Hunt graduated from Wake Forest in 1965.

WAYNE CALLOWAY. C. Wayne Calloway, Wake Forest Class of 1959, rose to become the CEO of PepsiCo and served his alma mater as chairman of the Board of Trustees.

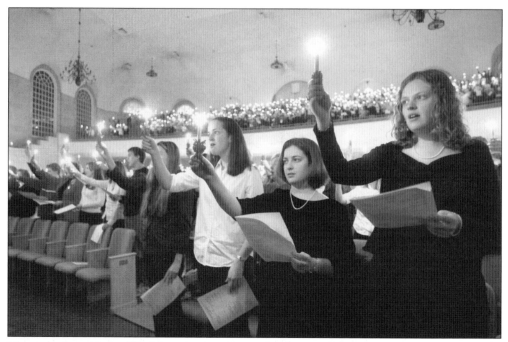

MORAVIAN LOVE FEAST. The Moravian Love Feast has been celebrated on campus since 1965, when a sophomore student of Moravian faith decided she wanted to share her tradition with the campus community.

PROJECT PUMPKIN. Project Pumpkin, an annual Halloween party for underprivileged children organized by Wake Forest students, brings over 1,100 Winston-Salem children to the Quad residence halls to trick-or-treat and enjoy carnival games and booths.

BRIAN PICCOLO CANCER FUND-RAISING EVENTS. Since 1980, undergraduate students have planned and conducted a number of annual events on campus to raise money for the Brian Piccolo Cancer Fund. The events include a golf tournament, softball tournament, casino night, and dance-a-thon. Over the last two decades the events have raised over $500,000.

PIEDMONT TRIAD RESEARCH PARK. Since the 1980s, R.J. Reynolds, Sara Lee, and Wachovia have left Winston-Salem, leaving the university, the medical school, and Baptist Hospital among the largest employers in the community. The Piedmont Triad Research Park is an ambitious initiative to attract technology companies to the community. In March 2003, North Carolina's Biotechnology Center, a 20-year-old creation of the state legislature, announced that its first regional office will be opened in the Piedmont Triad Research Park, one of four to be located throughout North Carolina.

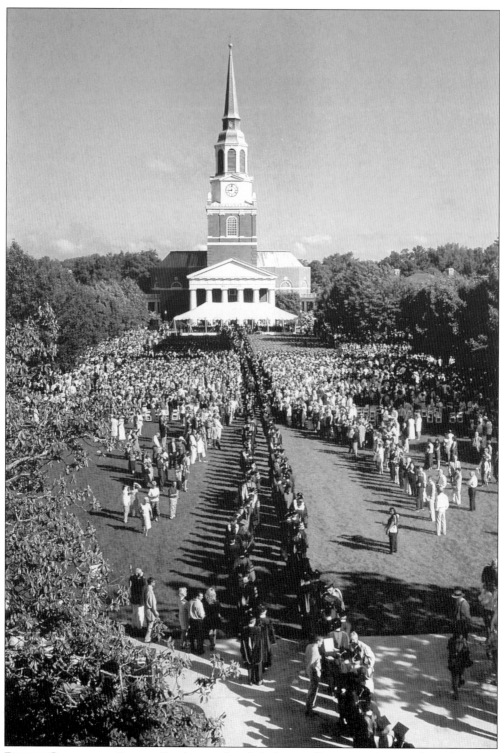

RECENT GRADUATION PHOTO. Students take their last walk across the Quad in this 2003 commencement photograph.